A VISION OF PARIS

The photographs of Eugène Atget

The words of Marcel Proust

The photographs of Eugène Atget
The words of Marcel Proust

Edited and with an Introduction by Arthur D. Trottenberg

Photographs from the Collection of Berenice Abbott

A VISION OF PARIS

Macmillan Publishing Co., Inc.

New York

Macmillan Publishing Co., Inc.
866 Third Avenue, New York, N.Y. 10022
Collier Macmillan Canada, Ltd.

The text in this volume is reprinted from

REMEMBRANCE OF THINGS PAST

by Marcel Proust, by permission of Random House, Inc.
Copyright 1924, 1925, 1927, 1929, 1930, 1932
and renewed 1951, 1952, 1955, 1956, 1957, 1959 by Random House, Inc.

Library of Congress Catalog Card Number : 62-19417

ISBN 0-02-620160-7

Reissue 1980

Printed in Italy and bound in Switzerland

For Markie, Jan and Mischa

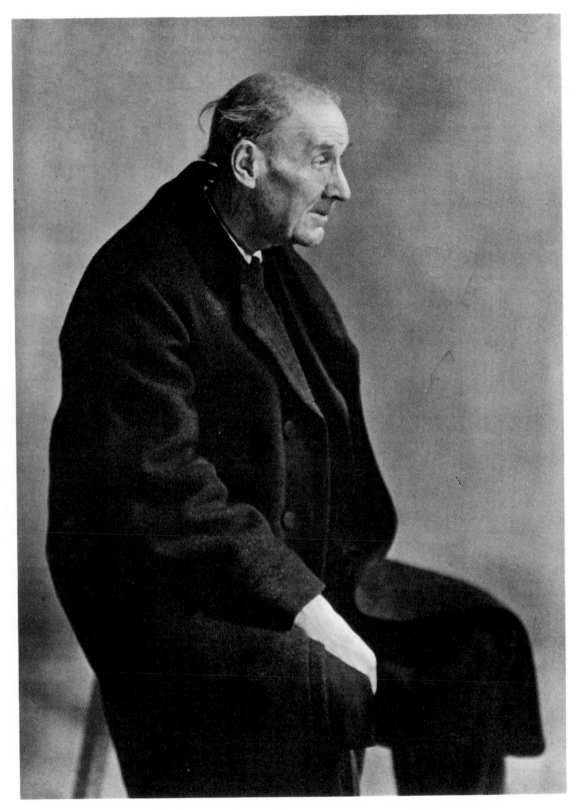

Eugène Atget photographed by Berenice Abbott

Author's Note

The publication of this book results in good part from the stimulus, encouragement and assistance of many people. I am grateful to Miss Berenice Abbott for the initial idea and for permission to reproduce the Atget photographs from her collection. My thanks too to Random House, Inc., for permission to quote from their two-volume edition of "Remembrance of Things Past" by Marcel Proust, translated by C. K. Scott Moncrieff and Frederick A. Blossom.

I am deeply indebted to Professor John William Ward of Princeton University, Professors H. Stuart Hughes and Harry Levin of Harvard University for their perceptive criticism of the manuscript. Mr. Ansel Adams, Beaumont and Nancy Newhall were generously helpful on all aspects of the history of photography and graphic reproduction. Peter and Jane Davison were an unfailing source of professional support, while Mrs. Dorothy Gillermann brought to the project her extraordinary editorial acuity and taste. Miss Edith Elder and Mrs. Ruth Morrison were more than helpful in preparing the manuscript—they were eager and interested participants.

This book owes much of its start, progress and completion to Mr. Cecil Scott of The Macmillan Company; in fact, without his creative intuition and warm editorial enthusiasm, it might not have been possible at all.

Arthur D. Trottenberg

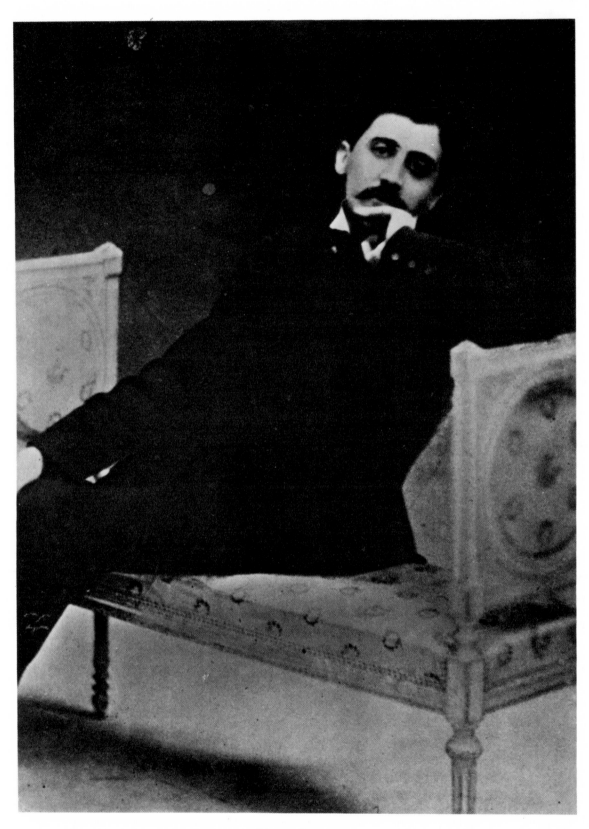

MARCEL PROUST

Introduction

Textual quotations from a novel coupled with pictures by a photographer who knew neither the novel nor its author might at first seem an uneasy marriage of convenience. This is not in fact such a superficial union, nor is it intended to be in any sense an "illustrated" book.

This volume does bring together the work of two superlative artists so that the art of one may both illuminate and reinforce the art of the other. Marcel Proust and Eugène Atget shared more than a consuming passion to record with creative insight the complex life and quick pulse of a great city at the turn of the century; they shared, too, an intense concern with the evocative power of the visual image as a means of aesthetic communication. In both text and photograph, the images presented by Proust and Atget are more than symbols of ideas and emotions—they are works of art, complete in themselves.

Yet these images are not isolated. They are in each case inseparably linked to the total work of each artist—enormous in scope and endlessly complex in meaning. For Proust and Atget Paris was more than a collection of streets, buildings and parks. It was a vast stage setting, which not only provided a proscenium for the actors but in many cases provided the visual stimuli for their movements. *Remembrance of Things Past* is concerned with people and the significance of their relationships, and much of Proust's microscopic examination of these relationships is colored and in part motivated by his exceptional sensitivity to the visual world. This same sensitivity characterizes the work of Eugène Atget, and the two artists, with lens and pen, provide a uniquely strong statement about a particular time and place.

The juxtaposition of words and pictures in this volume is, by deliberate intent, a loose one. An exact matching of photograph and textual image would be a futile exercise in shallow scholarship. The rich sensory world of Marcel Proust and Eugène Atget shrivels in meaning when subjected to the rigid classification of place names and geography. Hence the Paris considered here is not carefully defined in terms of its metropolitan borders. It is rather a fusion of time and place that must sometimes touch on areas important enough to be included within the Proustian dimension of Paris. For example, the description of the gardens of Combray, a country town in *Remembrance of Things Past,* is based in part on Proust's own memories of Auteuil, a residential

suburb between the western borders of Paris and the Bois de Boulogne. Paris, for Atget and Proust, was an idea—a condition of mind transmitted in their particular terms and not subject to arbitrary limitation.

<div align="center">*</div>

Fin-de-siècle Paris denotes more than the end of a century in a particular city. The year 1900 was the midway point of a remarkable thirty-year epoch that began with Victor Hugo's death in 1885 and ended with World War I. Legend and nostalgia have blurred the realities of this period, which actually began as a period of bitterness for France. The Third Republic was in its infancy, but there still remained the sour taste of the false security of the Second Empire and the deep defeatism resulting from the outcome of the Franco-Prussian War. For the aged writer Renan, it was no longer a world of hope. "France is dying; do not disturb her agony," he exclaimed to the poet Paul Déroulède.

He could not have been more wrong. Had he lived, Renan would have witnessed a France and a Paris bursting with vigor and accomplishment. Instead of a national funeral, it was the beginning of *la belle époque*. Instead of becoming the corpse predicted by Renan, France, for almost four decades after the founding of the Third Republic, was a fecund and lively leader in science, engineering, painting, drama, music, literature, philosophy and medicine.

In literature and philosophy the Paris of Marcel Proust was more than a center; it was the source of a torrent—a torrent of poetry, novels, novelettes, essays and articles. In a short span of time a number of isms were born and died. At the beginning of *la belle époque* the romanticism that had characterized French writing for much of the nineteenth century had given way to naturalism. It was the naturalism of Emile Zola—hard, biting, reformist—and the morbidly penetrating work of de Maupassant. Before the end of the period romanticism was to return under different names, transformed by the anarchy of the symbolist poets. Controversy abounded, and even the youthful Proust was much influenced by Henri Bergson's resounding challenge to materialism. The period was one of incredible vigor and variety of literary style, and any random sampling of writers must provide a distinguished list of men, sometimes separated in time and ideas, but providing a steady continuity of philosophical ferment: Alphonse Daudet, Maurice Barrès, Albert Sorel, Marcel Prévost, Anatole France, Pierre Loti, Romain Rolland, Stéphane Mallarmé, Paul Verlaine, Arthur Rimbaud, Colette, Jean Cocteau. An eclectic flock of willing expatriates came to live and write, including Gertrude and Leo Stein. The time was right, and there was always a place for new writers although they were sometimes faintly heard. In 1902 André Gide published his novel *Les Nourritures Terrestres,* which caused only a faint ripple in the sea of words.

Like Proust, Eugène Atget both contributed to and was influenced by the aesthetic fertility of *la belle époque*. He knew a number of artists of the period as friends and patrons, and like them, considered himself an *imagier*. He was a sympathetic witness to the rapidly changing direction of French painting.

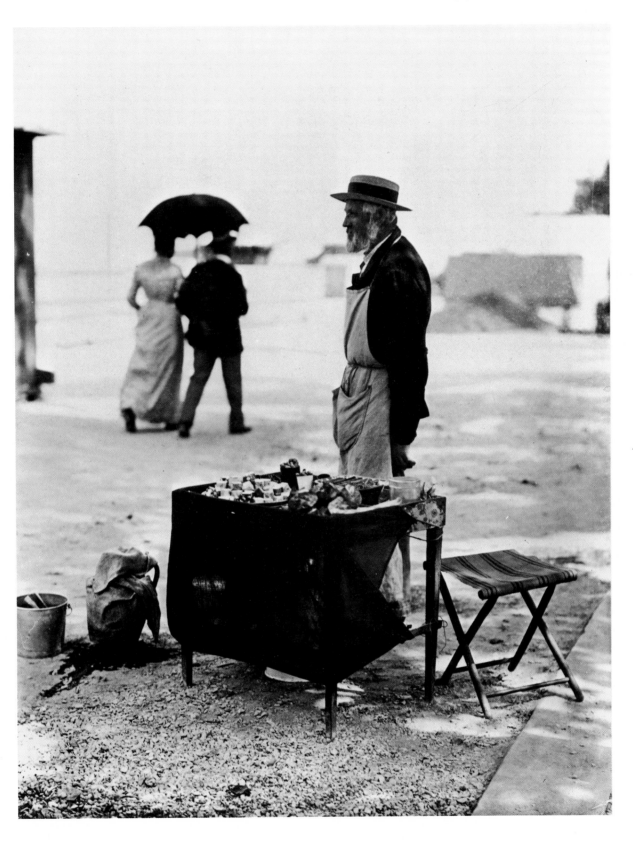

By 1886 impressionism had more or less run its course, and the last impressionist group show, while it met with no great public enthusiasm, at least ceased to draw howls of outrage from the critics. However, the early rebellion against neoclassicism and romanticism, against the cherished values established by David, Ingres, Delacroix, against the dictates of salons and academies, was to continue with full vigor in new directions. Five painters, including Seurat, Signac and Redon, founded the "Société des Artistes Indépendants" to continue the artistic rebellion of the original "Salon des Refusés." The ranks of the old and new revolutionaries, who overlapped in time within *la belle époque,* included a group of painters who, in terms of public acceptance, are surpassed only by the painters of the Italian Renaissance. They are household names today—Cézanne, van Gogh, Degas, Gauguin, Renoir, Rousseau, Matisse, Braque, Léger, Duchamp and Vlaminck. Their inspiration and atelier was Paris, and the heat of their aesthetic distemper drew others—Bakst and Chagall from Russia; Modigliani and Giorgio de Chirico from Italy; Picasso and Juan Gris from Spain. The thirty years that span the turn of the century in Paris saw the development of a dozen new movements, including symbolism, fauvism, Dada, cubism and surrealism. These men were the compatriots of Proust and Atget, and it is immaterial whether they knew one another or not. In their creativity and courage they symbolize a time and place whose very atmosphere sustained the restless need to express one's self to the limits of one's capacity.

At the start of *la belle époque* Paris, as a city, was unmatched for her charm and gentle pace of life. There was a village flavor about the bridle paths along the Champs Elysées and the rustic leisure of the Bois de Boulogne. Farm animals grazed among the windmills of Montmartre, and Montparnasse seemed rural and far away. Within a few years, however, the city began to expand rapidly as the population grew, and within a decade had engulfed many small towns at its outskirts: Marbeuf, Passy, Montmartre, Batignolles, and even the paradise of Proust's summer holidays, Auteuil. Industrialization and the automobile rapidly altered the city. By 1900 there were thousands of factories in the Paris region, and the horse-drawn omnibus had given way to the first branch of the Metro system. The gas mantle was replaced by the electric light bulb, and the cries of street vendors, so sweetly remembered by Proust, were lost in the roar of traffic.

Yet the bittersweet nostalgia so obvious in the work of Marcel Proust and Eugène Atget is not primarily directed to buildings, streets and parks. It is, rather, concerned with the pulsation of life in a city which once had time to nourish its inhabitants in more meaningful relationships than obtain today. Physically, Proust and Atget would still recognize their city. True, there are new buildings; some streets are altered; the Metro roars underground, and traffic clogs all thoroughfares. Yet despite two world wars, the skyline is much the same as it was sixty-two years ago, and the Seine, complete with painted barges, saunters slowly through the city. In the hush of dusk there is an occasional street vendor's cry to be heard, and on festive days there are still parades of chasseurs resplendent in gold braid and polished helmets. Proust and Atget would, however, notice a grievous alteration in the life of the city they knew so well: the dimension of time as they understood it has vanished.

For Proust and Atget time was more than just the measure of growth and decay. It was the vital ingredient of one's relationship with one's fellowmen. Time for Atget was a slow amble through the Bois de Bou-

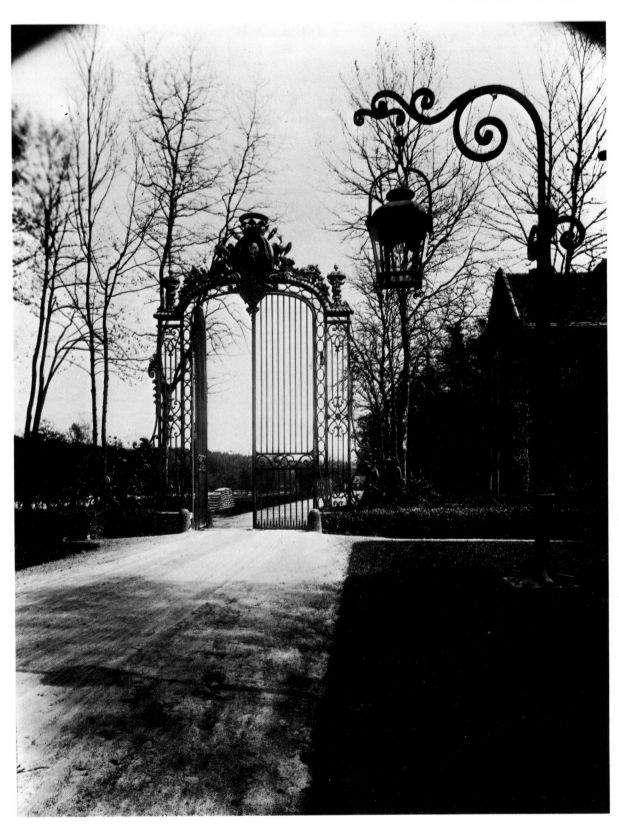

logne and a chance meeting with a delivery boy or street vendor who would pose willingly and inquire carefully after Atget's health and work. For Proust, too, time was the unhurried dimension which made it possible for people to talk, philosophize, compliment, reprimand and sympathize. It is people and their time for each other he would look for in vain today. For all its outward similarities, the city of *Remembrance of Things Past* has vanished. In these terms, Proust saw clearly the end of his city just before his death, and marked its significance in the last paragraph of his monumental novel: "If, at least, there were granted me time enough to complete my work, I would not fail to stamp it with the seal of that Time the understanding of which was this day so forcibly impressing itself upon me and I would therein describe men—even should that give them the semblance of monstrous creatures—as occupying in Time a place far more considerable than the so restricted one alloted them in space, a place on the contrary, extending boundlessly since, giant-like, reaching far back into the years, they touch simultaneously epochs of their lives—with countless days between—so widely separated from one another in time."

*

The public knows much today of Marcel Proust the legend, the hypochondriac; the eccentric of the cork-lined room at 102 Boulevard Haussmann, habitué of the fashionable salons of the Faubourg Saint-Germain; intimate of Anatole France, Barrès, Fauré, Léon Blum, Gide, and invalid author of a lengthy and singular novel. Undoubtedly a superficial examination of the bizarre aspects of Proust's life is easier and more titillating than the harder but more rewarding effort involved in reading his novel, *Remembrance of Things Past*. The bare bones of his biography, however, provide simply milestones of time which are significant only when considered in relation to the events of *Remembrance of Things Past*. The quality, the character, the very meaning of Proust's existence, are to be found only by understanding his immensely complex fictional world and its inhabitants. Saint Loup, Swann, Albertine, Charlus speak for Proust and of Proust, and we must know them well if we are to understand the terms and raison d'être of his life.

Marcel Proust was born on 10 July 1871 at 96 Rue La Fontaine, Auteuil, a residential suburb of Paris near the Bois de Boulogne. His father, Adrien Proust, a distinguished French physician, was then *Chef de clinique* at the Charité hospital in Paris, and later became a leading figure in European medicine. His mother, Jeanne Weil, was the sensitive, beautiful daughter of Nathée Weil, a wealthy Jewish stockbroker whose family originally came from Lorraine. The family, including his younger brother Robert, was a strong and happy unit, and within its indulgent and devoted relationships Proust was to find his greatest happiness.

It is possible that the overly close, sometimes cloying interdependence of this family circle was responsible for some of Proust's later difficulties. He was never, in later years, able to divest himself of a desperate and continuing need for his father's support and his mother's love. It is possible that overdependence is linked in some way to asthma, the ailment which first struck Marcel at the age of nine, and destined him to lead the restricted life of an invalid. Ill health and severe asthmatic attacks, however, did not seem to hamper Proust's successful career at the

Lycée Condorcet, which, like many French schools of its kind, maintained a strong emphasis on the classics and modern literature. In this congenial atmosphere, the precocious young Proust devoured Baudelaire, La Bruyère, Madame de Sévigné, Musset, George Sand, Lemaitre and Maeterlinck. Steeped in and permanently committed to literature and philosophy, Proust passed his baccalaureate examination in 1889 with a second prize in mathematics, a third for physics and the Prize of Honor for philosophy. In deference to his father, who wished him to become a diplomat or lawyer, Proust entered the Ecole des Sciences Politiques and the Ecole de Droit. He was, however, completely indifferent to law and diplomacy, and while he passed his examination in the Ecole des Sciences Politiques, he failed the second half of his law examination. Proust's formal schooling ended with his attendance at lectures at the Sorbonne with no definite goal in view. But the period was not without value. Proust took full advantage of the opportunity to study with the historian Albert Sorel and the philosophers Henri Bergson and Paul Desjardins.

Throughout his early years Proust tenaciously sought for himself a secure position in the glittering aristocratic world of the Faubourg Saint-Germain—a world he was later to dissect with such skill in *Remembrance of Things Past*. His charm, wit and discrimination in matters of art, music and literature ensured his social progress, and made him a welcome guest in those salons which brought together literary figures with discerning members of the aristocracy: the salons of Mme. Straus, Mme. Henri Baignères, Mme. Aubernon and Mme. de Chevigné. He quickly became a familiar of a number of important names in French literature: Daudet, the pompous Anatole France and the elegant Comte Robert de Montesquieu, who did much to introduce Proust to the more exclusive salons, and who was to provide one of the models for the fictional Baron de Charlus.

In 1896 Proust published his first book, *Les Plaisirs et les Jours,* a collection of articles, poems and stories with a preface by Anatole France and a few pages of music by Reynaldo Hahn. There was little in this collection of oddments to indicate the work yet to come, and critics for the most part treated it lightly or not at all. With the exception of the premature *Jean Santeuil* and a continuing variety of articles and reviews, Proust published nothing more serious or lenghty until the monumental *A la Recherche du Temps Perdu*. Proust began now, perhaps unconsciously, to marshal his energy and resources for the epic document of his career.

After the publication of *Les Plaisirs et les Jours,* Proust gave way with fatalistic resignation to the restrictions imposed by ill health, and began the gradual withdrawal from life that persisted until his death in 1922. Pleurodynia, rheumatic fever and bronchitis joined with the chronic asthma to provide a readily available motive for his inability to participate in the world of affairs. He continued his warm relationship with old friends, and even managed to acquire new ones, but surrendered the successful social and salon existence he had so long sought and finally attained.

Biographers have indulged in lenghty and labored analyses of Proust as a neurotic and as an invert. There is little doubt he was both. But much of Proust's strength and sharpness of insight is due to his invalidism. Confinement to his room and bed provided the fullest opportunity for his extraordinary powers of memory and imagination to explore and reconstruct the world he had known. He was able, as in a sterile laboratory, to view

the world and analyze it without the daily abrasion and conflict of the world of action. The term "invert" has always carried with it a certain moral odium, and Proust, during his lifetime, suffered greatly from the physical and emotional problems created by his aberration and from the whispered accusations that surrounded him. The measure of his anguish is found in one remarkable chapter of *Remembrance of Things Past* where he makes a lengthy and moving plea for understanding of the invert's plight.

Despite his delicacy of health and mind and his early devotion to the attitudes of the aristocracy, Proust was not without courage in matters that affected his deepest moral convictions. When the Dreyfus case exploded in 1898 and tore France into bitter factions, Proust was among the first to proclaim himself a Dreyfusard despite the fact that his father and many of his most esteemed friends held the opposite position. Through the initiation of petitions and the writing of articles, he played a minor but active role in the development of the "affair."

Dr. Adrien Proust died in November 1903, and Marcel's mother two years later. The impact of bereavement on Proust can best be measured by his own words written to Montesquieu shortly after her death: "My life has now lost its only objective, its only sweetness, its only love, its only consolation. I have just lost her whose incessant vigilance brought me—in peace, in tenderness—the only honey of my life."

Fifteen months after the death of his mother Proust moved to his most famous address—102, Boulevard Haussmann. Here his hypersensitivity to outside noise led him to panel the four walls of his bedroom with cork. In this semisealed mausoleum, cluttered with medicaments, and fetid with asthma fumigations, Proust, wrapped in layers of sweaters and mufflers, was to labor for thirteen years on his remarkable novel. An excessive use of drugs, both sedatives and stimulants, blurred the separation of night and day, of waking and sleeping, and in fact, the remembrance of things past became the important, the only reality.

While Proust had originally envisioned his novel as a single volume, successive revisions and the addition of new material led him to organize it in three volumes entitled *Swann's Way, The Guermantes Way* and *The Past Recaptured*. The first volume, *Swann's Way* was published in November 1913 by Bernard Grasset after being refused by several publishing houses. The two remaining volumes were not published until after the war, and in the meantime Proust continued laboriously to enlarge and revise his material. While the first volume met with considerable public apathy, the next two were to be greeted with enthusiasm. Proust was to savor in full, for the few years before he died, both critical acceptance and the acclaim of a broad and excited reading public. His happiness was crowned by receiving the Prix Goncourt in December 1919.

In the last years before his death, and despite his accelerating physical deterioration, Proust continued his prodigious labor, rewriting, revising, correcting proofs and badgering his publisher to increase sales. During the last year of his life Proust recognized how little time was left. His seclusion became more complete, and he devoted his waning energy toward the completion of the great work.

He died in October 1922, correcting proofs and dictating revisions almost to the end. His fevered imagination served him one last grisly image as he turned to his devoted housekeeper, Celeste Albaret, to speak of death: "Celeste! Celeste! she's very fat and quite black—she's dressed entirely in black. I'm frightened."

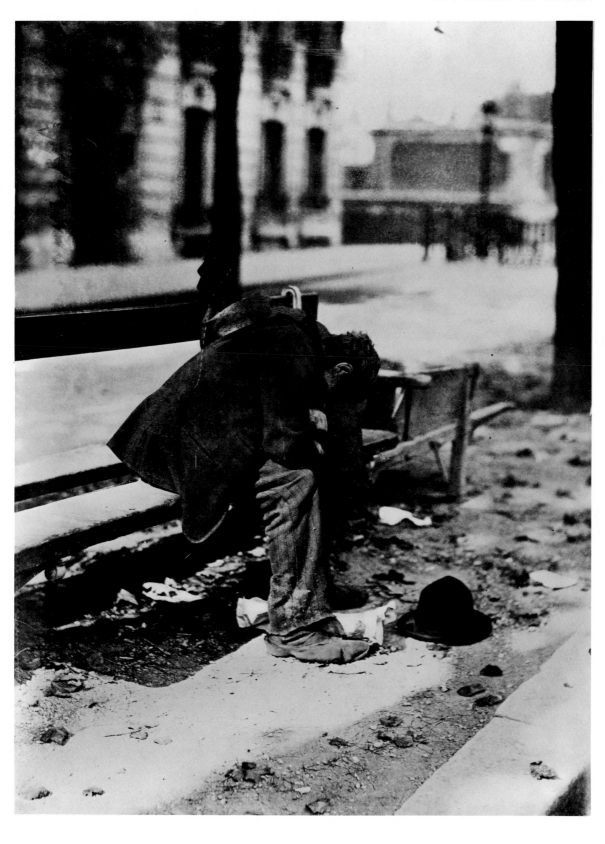

Our knowledge of *la belle époque* in Paris is remarkably complete. Writers, painters, musicians, actors—all seemed, in the natural ferment of interaction, to make the story of their lives clear and readily available to the historian. Eugène Atget was an exception, and it is a sad but inescapable fact that the record of his life is scant and poorly documented. He was from the beginning a relentlessly dedicated artist with little time or talent for self-aggrandizement or the cultivation of friends. Stringently self-imposed rules of diet, hygiene, dress—of life itself, defined his relative isolation from the social life of a city bursting with articulate, uninhibited creative energy. We owe our fragments of biographical fact to a few perceptive artists who recognized, while Atget was still alive, that here was a fellow artist of the first rank pioneering in a medium that must some day be recognized as a full partner in the visual arts. Among them were André Calmettes, actor and motion picture director; Man Ray, painter and photographer; and a woman who has devoted an incredible amount of time and energy to the public recognition of Atget—Berenice Abbott, distinguished American photographer.

The repeating pattern of tragedy and loneliness for Atget was established from the start. Born in Bordeaux in 1856 of bourgeois French parents, Jean Eugène Auguste Atget was left an orphan at an early age and spent his tender years with his uncle, a railroad stationmaster in the Department of the Gironde. It was natural, in Bordeaux, for a poor French youth without prospects or education to turn to the sea for his living, and Atget, while still an adolescent, served under sail for a number of voyages as cabin boy and sailor.

The sensitive Atget found life at sea hard and unrewarding, and recognizing in himself a need for creative expression, he turned to the theater for a new career. As an actor-comedian Atget toured the provinces and environs of Paris playing "third roles." His physique sharply limited his opportunities to play more heroic parts, and Atget came to the bitter realization that again the years were wasted and he could not hope to make his living in the theater. These years were not completely barren, however, for it was during this period that he established the warmest and most lasting personal relationship of his life. He took as his mistress an actress ten or twelve years his senior, who remained with him as Madame Atget until she died at the age of eighty-four, a few years before his own death.

At the age of forty Atget took his savings and his mistress to Paris, where once more with undiminished optimism and enthusiasm he turned for a while to painting. Again his hunger for expression and his talents were not compatible, and the results were frustation and failure. Finally in 1898 the no longer youthful Atget began his lifework in photography. "Photographe d'art," he called himself at the beginning, and he proudly asserted his new professional status with a hand-lettered sign on the door of his apartment-darkroom at 31 Rue Campagne Première—"Documents pour artistes." Without cynicism or doubt, Atget threw himself furiously into his new career. He was certain that in photography he had at last found his opportunity to make his aesthetic statement, as an artist, about the world around him. We know from his friend André Calmettes, that from the beginning, "He already had the ambition of creating a collection of everything artistic and picturesque in and about Paris."

Rising almost always before dawn to avoid the blur of traffic in his negative, and armed with his cumbersome camera, tripod and heavy bag of glass plates, Atget became a curious and familiar figure of the Paris

streets: a bent silhouette always dressed in an immense threadbare coat, hands blackened by chemicals and the whole topped by an archaic round hat. His vision, however, was always clear, his self-imposed mandate carefully defined—to interpret honestly but in terms of his own poetic instinct, the purely photographic image of Paris. Atget was concerned with more than a unique visual record of monuments, architecture and nature. His main concern was for people—the conditions and meaning of their existence as well as the futility and grandeur of their buildings. Atget took almost no isolated photographs. He treated his subjects in complete and varied series from a number of camera positions. It was not enough to take a photograph of a street. It was important for him to show the street as a viewer might see it if he turned his head in various directions. He felt the need to show the process of growth and decay in a great city, and hence would photograph a building, as for example the basilica of Sacré-Cœur, in various stages of construction. He applied the same technique to the demolition of several buildings in Paris. He continually varied his approach to a subject, not only with camera angles, but from a distance to extremely close up. His technical virtuosity, considering the inflexibility of his equipment, is, even today, enormously impressive. Among the subjects he treated with exhaustive thoroughness and in series were trees, flowers, shop windows, streets, cafés, brothels, monuments, buildings, street vendors, rag-pickers, St. Cloud, Versailles, the Bois de Boulogne and architectural detail of every kind.

Atget's photographic technique was simple although somewhat old-fashioned even for his day. He used a large and awkward view camera with a rapid rectilinear lens of unknown focal length. It was, in all probability, a short focal length lens since many of his pictures show distorted perspective and in many cases the top of his negative plates (18×24 centimeters in size) did not carry the full image. He printed his pictures on albumen or gelatino-chloride printing-out paper, and toned them brown with gold chloride. Unlike many photographers he did not crop, trim or burn in his pictures in the darkroom. His initial vision always prevailed, and the end result was devoid of trickery. His ability to photograph detail with exceptional clarity and retain it in the finished print was a photographic tour de force.

The economic existence of a photographer in the Paris of 1900 was not an easy one. With the exception of studio portraits there was almost no market for pictures, particularly pictures of buildings and streets. At last "one beautiful day" a Monsieur Luc-Olivier Merson bought a print from Atget for fifteen francs, and Atget's faith in his work was renewed. He began a slow but steady sale of statues, fountains, churches and monuments to the Paris museums. Artists, including Braque and Utrillo, began to buy his photographs as an aid to memory, and in some cases worked directly from them to canvas. This period prior to World War I was a proud and happy time for Atget. He was at last making a living in the work of his choice and was too busy applying his vision to his massive project to worry about fame. Nevertheless, writers, playwrights and painters began to find their way to the fifth floor workshop at 31 Rue Campagne Première. Marcel Duchamp, Picasso and Man Ray searched him out, and Victorien Sardou urged him to photograph ancient buildings and streets soon to be demolished. The pattern of his life remained constant, however, and the fruitful, happy years came to a harshly abrupt and bitter end. World War I ended the accelerating growth of Atget's career and his increasing acceptance by fellow

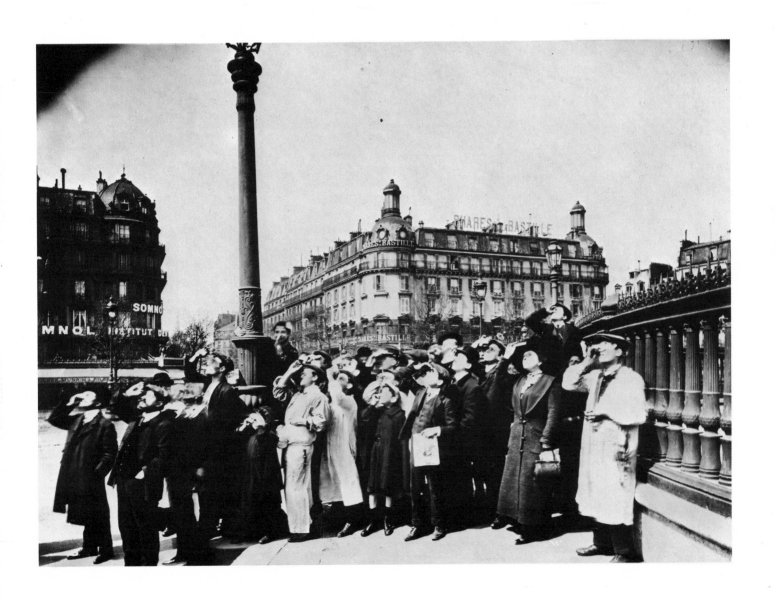

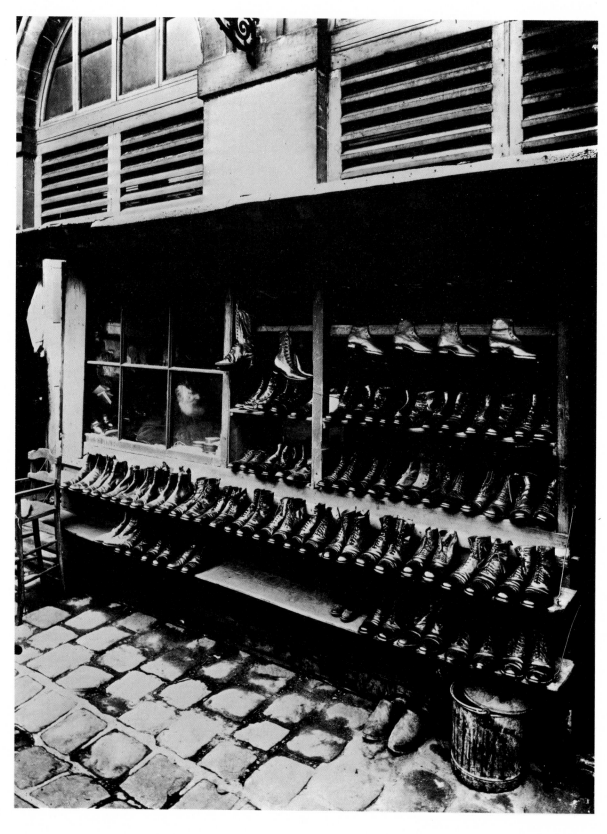

artists. His prints stopped selling, his clientele dispersed, and his brief sense of participation in a golden era vanished. There was still some important work to be done. Les Monuments Historiques bought a series of pictures of monuments and buildings destroyed or damaged during the war, and in 1921 he accepted a commission to photograph the city's brothels for a book on prostitution by Dignimont. Despite these sporadic sales, however, his spirit was crushed, and he lived mostly on the sale of his accumulated files as he produced less and less. His feeling of desperation and loneliness was deepened by the death of Madame Atget in 1926.

Until this time Atget had received no public recognition. There had been no shows, no salons, and not a single picture of his had been reproduced in a photographic magazine. In 1926, however, the year of his greatest discouragement, he began to receive his first concrete professional acknowledgment. *La Révolution Surréaliste,* the official publication of the surrealist painters, bought and published four of his photographs. Of even more significance that same year was the discovery by Berenice Abbott, then an assistant to Man Ray, of Atget and his work. She began steadily to visit the tiny atelier, and bought as many prints as her few spare francs would allow. It is largely due to her early discernment that Atget is recognized today for the artist he was.

Atget became seriously ill in 1927. His health had been steadily sapped by his peculiarly rigid diet of milk, bread and sugar, and his spirit weakened by loneliness and defeat. In August he sent a note by messenger to his old friend André Calmettes: "I am at my last gasp, come quickly!" Calmettes arrived too late, and Atget died alone and helpless. It was Calmettes, too, who in a letter to Berenice Abbott, penned the only appropriate epitaph: "May all those who are interested in what he loved so much, that is to say Paris and its art treasures, or in looking at the beautiful pictures Atget made of it, still pronounce sometimes his name, which was that of a strong, courageous artist, of an admirable *imagier*."

Atget's contribution to photography as an art is even more remarkable when considered in relation to his nineteenth century technique and his isolation from the mainstream of international photography. By the turn of the century photography had made great strides. The more efficient anastigmat lens was replacing the rapid rectilinear lens; the highly flexible gum-bichromate process had been invented, and there were constant improvements in the development of new films and papers. Alfred Stieglitz and Edward Steichen in the United States, Peter Henry Emerson in England and Robert Demachy and C. Puyo in France had shown what the new equipment and advanced technique could do. These men were also desperately eager to establish photography as a respectable partner in the visual arts. They battled furiously among themselves about technique and the merits of naturalism versus pictorialism. Salons and photographic societies proliferated with great rapidity, and in 1893 five photographers, including George Davison, formed a group in London called "The Linked Ring," which was to establish once for all the legitimate claim of photography as an art. They were joined by others: Heinrich Kuhn and Hugo Henneberg in Vienna and a particularly vigorous group in New York including Steichen, Frank Eugene and Clarence H. White. In 1902 the Americans formed their own group, called the "Photo-Secession" under the leadership of Stieglitz, who set forth the credo for all photographers: "Photography is my passion. The search for truth my obsession."

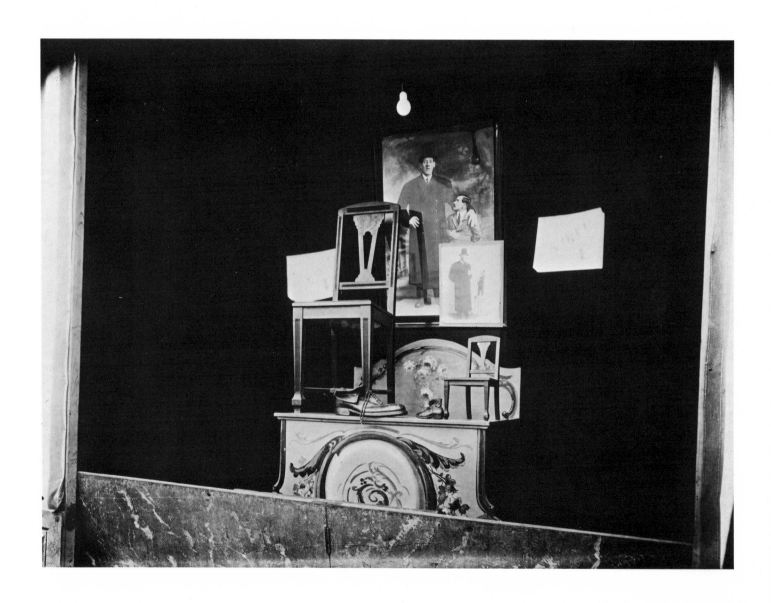

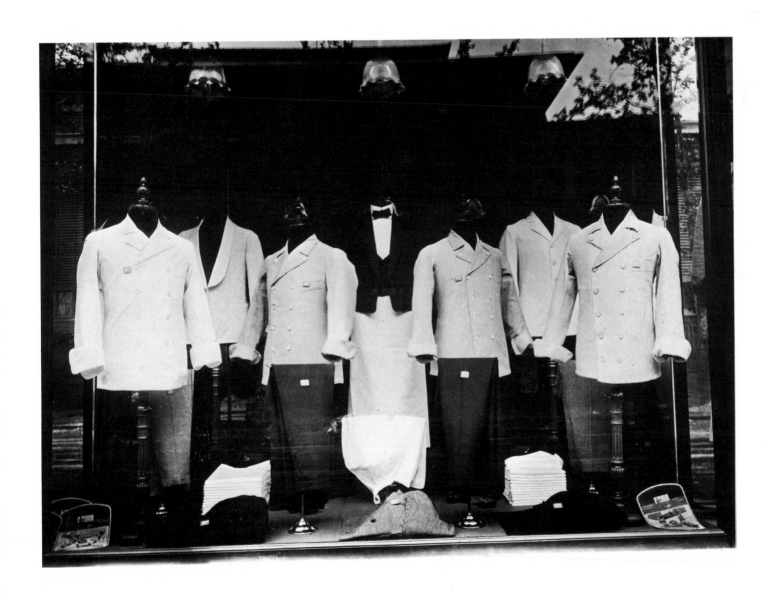

In France itself there was a long tradition of pioneering activity in photography. In the early part of the nineteenth century Nicéphore Niépce had been among the very first to succeed in permanently fixing the camera's image in a negative-positive process called *heliography*. Louis Daguerre improved on Niépce's process by developing the *daguerreotype* in 1837 and photography became available to the general public. The great portrait photographer Nadar opened his Paris studio in 1853, and produced wonderfully simple and revealing portraits of the great figures of his day: Charles Baudelaire, Eugène Delacroix, Gustave Doré, Honoré Daumier and Sarah Bernhardt.

There is no evidence to indicate that Atget was aware of the tradition or sensitive to the restless ferment among his fellow photographers. His pace and progress were seemingly untouched by the new developments, and yet his own contribution, although not recognized for three decades, was enormous. He cared not a jot whether his approach was classic, naturalistic, impressionistic or pictorial. He worked freely with them all, but his great work was in what historians of photography call the "straight approach." Atget, like Mathew Brady in the United States, was among the first to demonstrate the latent poetic power in the honest use of the camera. He clearly proved that the photographer as an artist can select, compose and communicate a meaningful moment in time with sensitivity and skill as his main instruments, and the camera, like the painter's brush, incidental to the act. Unlike his colleagues, he did not suffer from an artistic inferiority complex or the guilt feelings of a frustrated painter. He was a pure photographer working in a medium that offered certain potentialities and certain limitations, and he worked comfortably and creatively within them.

The tangible legacy left by Eugène Atget was enormous—more than 10,000 glass plate negatives and original prints. A considerable number of negatives were acquired for almost nothing by the Archives de Documentations at the Palais Royal. The largest collection, however, is owned by Berenice Abbott in the United States. Atget's complete work has not yet undergone thorough scholarly scrutiny, and this immense store of visual source material for history, art and architecture remains almost untapped.

The intangible legacy is the existence of Atget's photographs as works of art. The formal question of whether photography is an art may never be fully resolved. Nevertheless, if one chief criterion of a work of art is its power to rouse certain emotions in the spectator, then Atget's pictures must be considered as such. These relatively small, colorless bits of paper have the power to awe or depress; to evoke melancholy, joy, sympathy. These emotions in themselves, however, are transitory and quickly forgotten unless the artist interprets them with integrity and in terms of his own poetic vision. This Eugène Atget has done.

ARTHUR D. TROTTENBERG

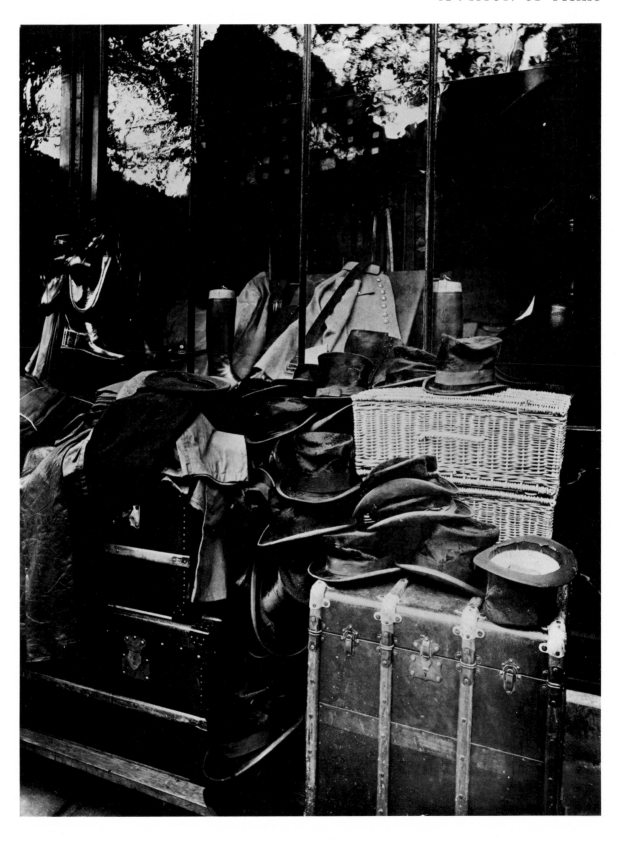

Profile of the City

. . . the golden morning brightness of a Parisian sidewalk.

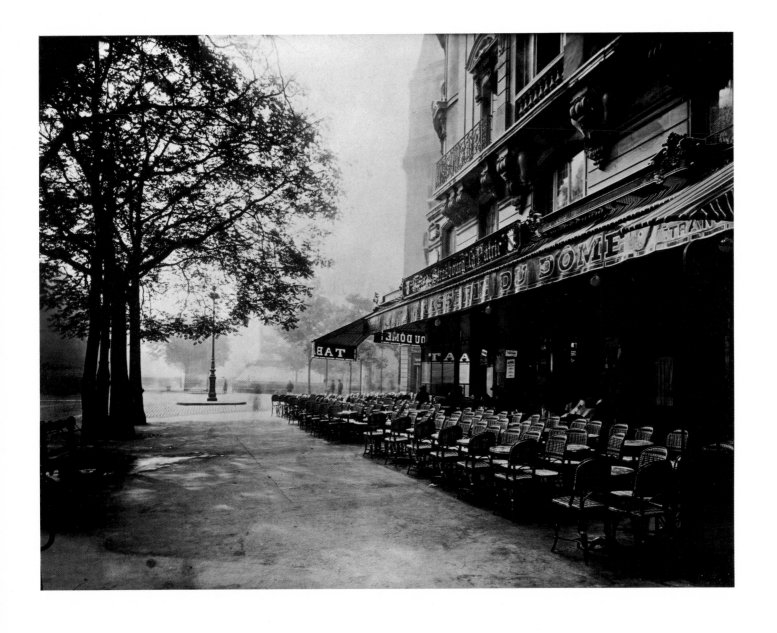

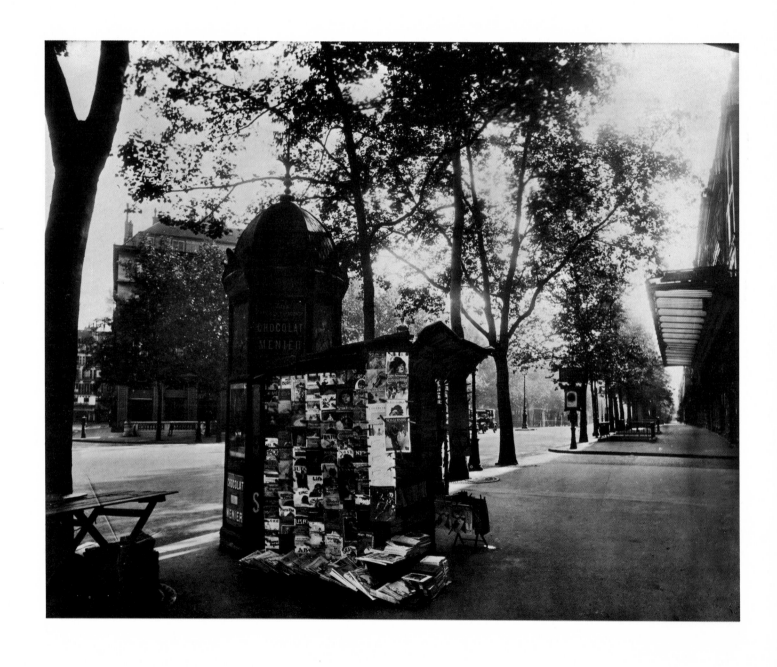

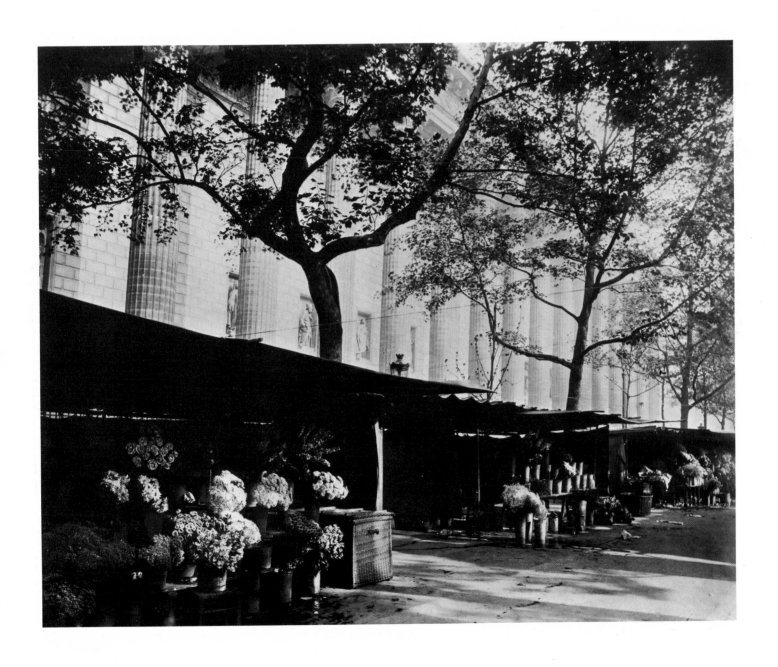

. . . a restaurant where they looked as if they kept a very good little family table.

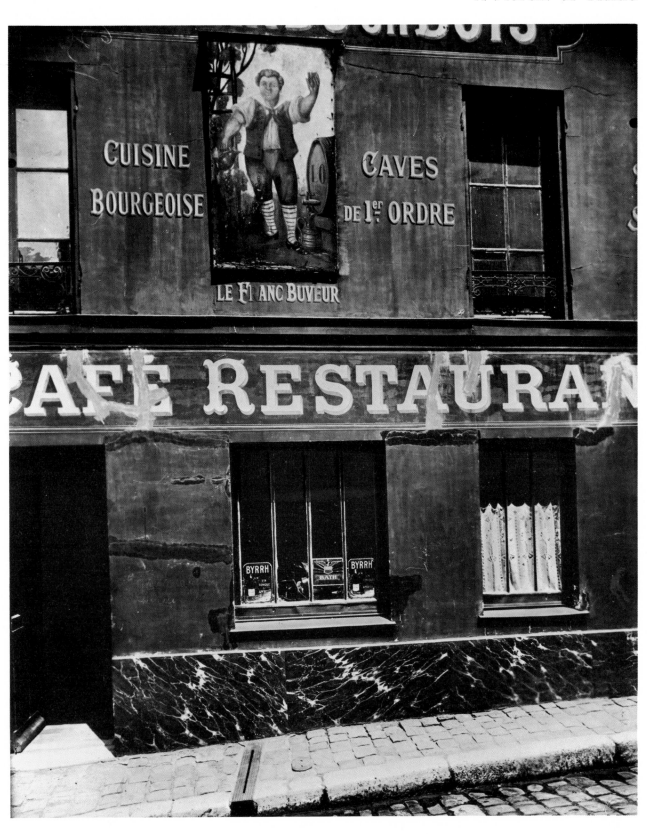

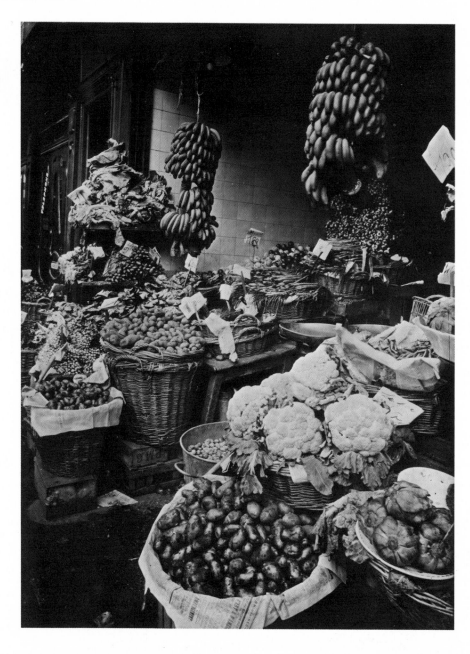

And I felt that, should I ever have to leave this aristocratic quarter—unless it were to move to one that was entirely plebeian—the streets and boulevards of central Paris (where the fruit, fish and other trades, stabilised in huge stores, rendered superfluous the cries of the street hawkers, who for that matter would not have been able to make themselves heard) would seem to me very dreary, quite uninhabitable, stripped, drained of all these litanies of the small trades and peripatetic victuals, deprived of the orchestra that returned every morning to charm me.

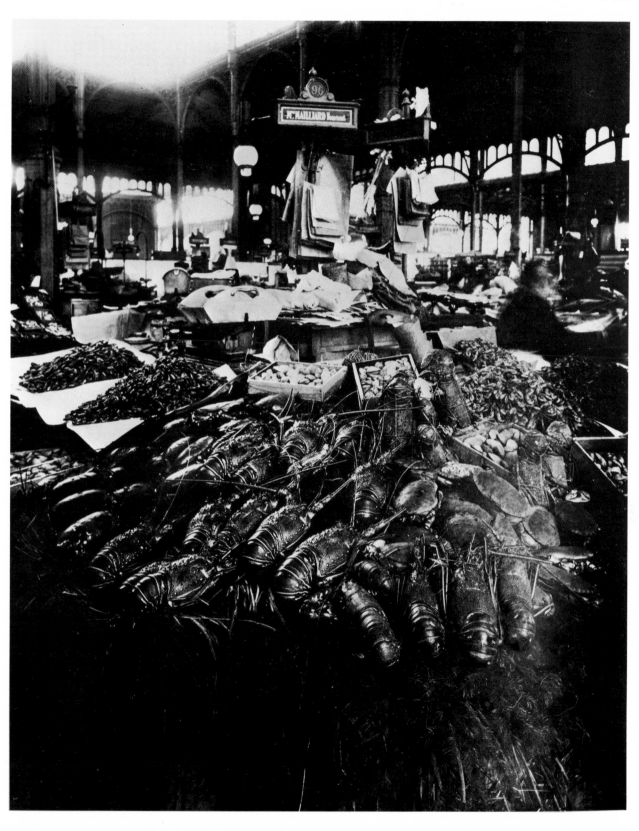

Every morning I would hasten to the Moriss column to see what new plays it announced. Nothing could be more disinterested or happier than the dreams with which these announcements filled my mind, dreams which took their form from the inevitable associations of the words forming the title of the play, and also from the colour of the bills, still damp and wrinkled with paste, on which those words stood out. Nothing, unless it were such strange titles as the *Testament de César Girodot* or *Œdipe-Roi,* inscribed not on the green bills of the Opéra-Comique, but on the wine-coloured bills of the Comédie-Française, nothing seemed to me to differ more profoundly from the sparkling white plume of the *Diamants de la Couronne* than the sleek, mysterious satin of the *Domino Noir;* and since my parents had told me that, for my first visit to the theatre, I should have to choose between these two pieces, I would study exhaustively and in turn the title of one and the title of the other (for those were all that I knew of either), attempting to snatch from each a foretaste of the pleasure which it offered me, and to compare this pleasure with that latent in the other title, until in the end I had shewn myself such vivid, such compelling pictures of, on the one hand, a play of dazzling arrogance, and on the other a gentle, velvety play, that I was as little capable of deciding which play I should prefer to see as if, at the dinner-table, they had obliged me to choose between rice à l'Impératrice and the famous cream of chocolate.

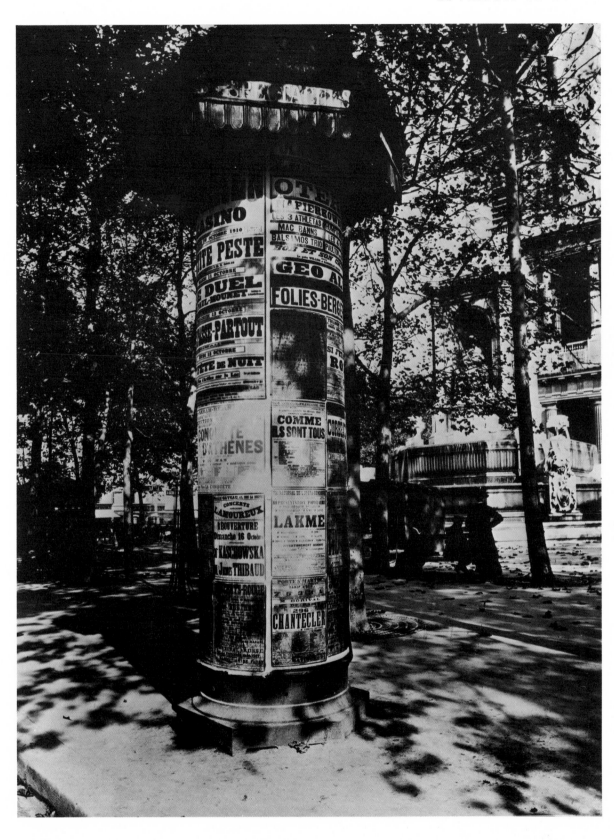

On certain fine days the weather was so cold, one was in such full communication with the street that it seemed as though a breach had been made in the outer walls of the house, and, whenever a tramcar passed, the sound of its bell throbbed like that of a silver knife striking a wall of glass.

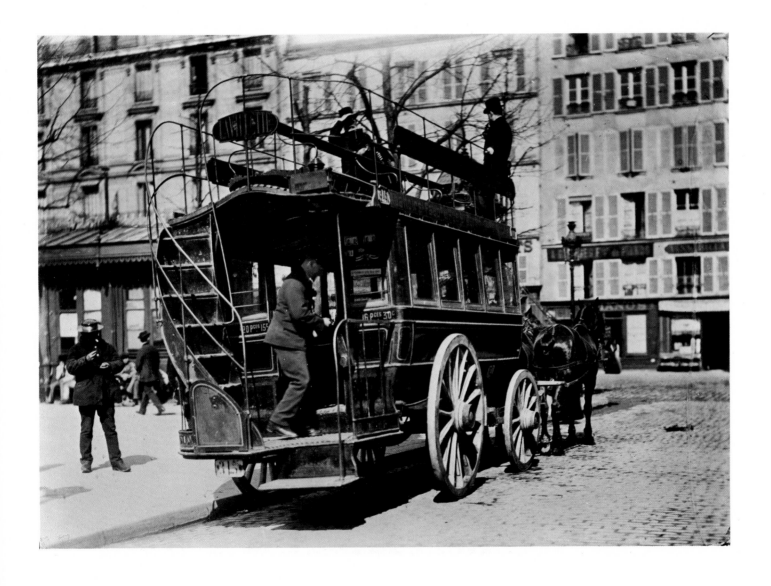

From my darkened room, with a power of evocation equal to that of former days but capable now of evoking only pain, I felt that outside, in the heaviness of the atmosphere, the setting sun was plastering the vertical fronts of houses and churches with a tawny distemper.

— determination to document all of the architecture and street scenes of Paris before their disappearance to modernization.

My name is Selena Vang. The title of my book is "A Vision of Paris". The author author of my book is Eugene Atget. The photogerher I have picked is Berenice Abbott

how Paris looked like.

The photographer i have picked is Berenice Abbott

My name is Selena Vang. The title of my book is "A Vision of Paris". The author The author of the book is Eugene Atget. Some images I found interesting were these (show pics) I found these photos interesting because how it shows how Paris looked like and how Paris is important to them, they want to show Paris in the olden days through street scenes and architecture/buildings since they knew Paris will change as time goes by to the modern world.

photos of

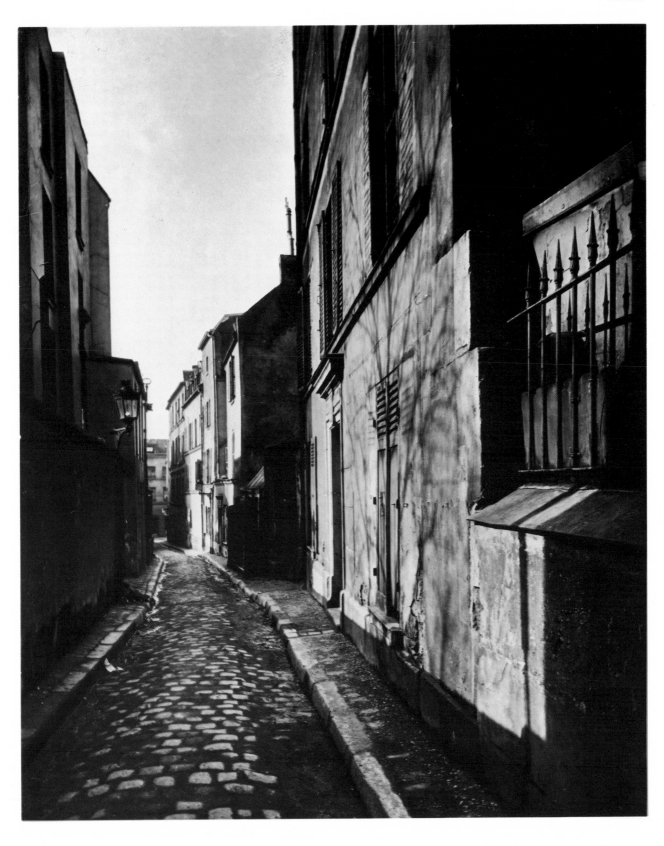

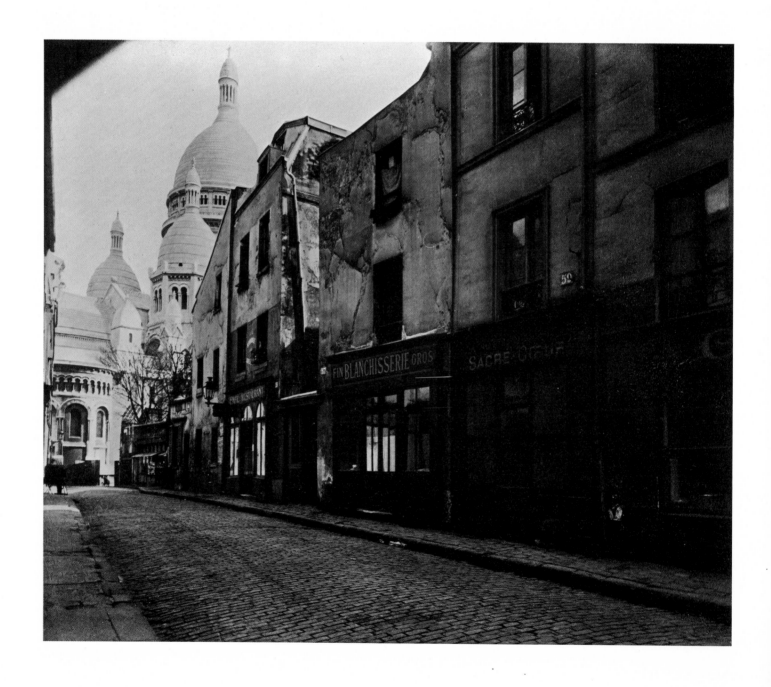

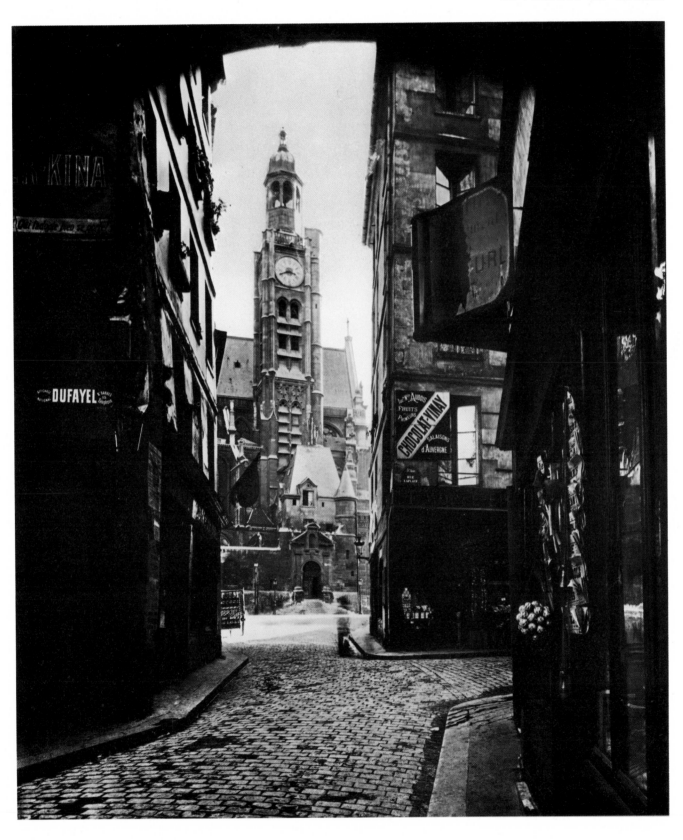

While as for her figure, and she was admirably built, it was impossible to make out its continuity (on account of the fashion then prevailing, and in spite of her being one of the best-dressed women in Paris) for the corset, jetting forwards in an arch, as though over an imaginary stomach, and ending in a sharp point, beneath which bulged out the balloon of her double skirts, gave a woman, that year, the appearance of being composed of different sections badly fitted together . . .

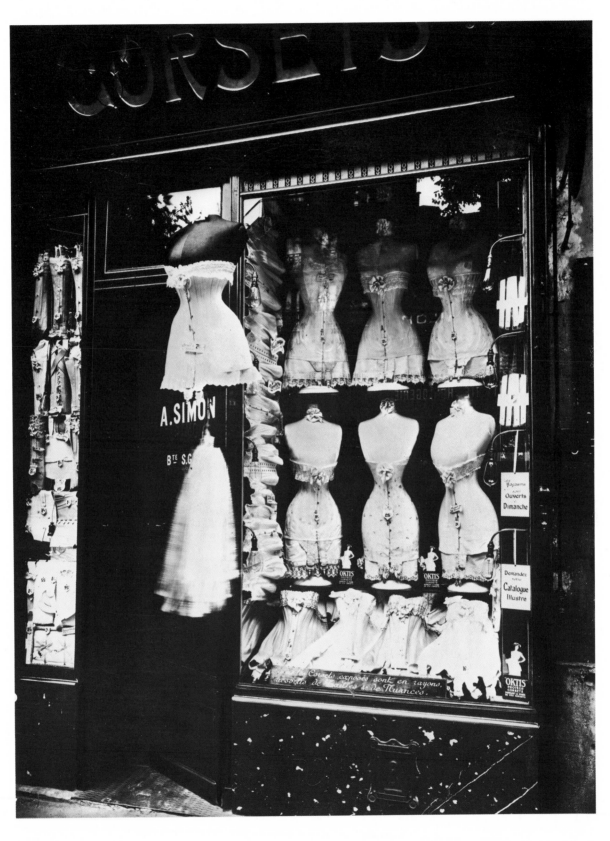

It must be remarked that Odette's face appeared thinner and more prominent than it actually was, because her forehead and the upper part of her cheeks, a single and almost plane surface, were covered by the masses of hair which women wore at that period, drawn forward in a fringe, raised in crimped waves and falling in stray locks over her ears.

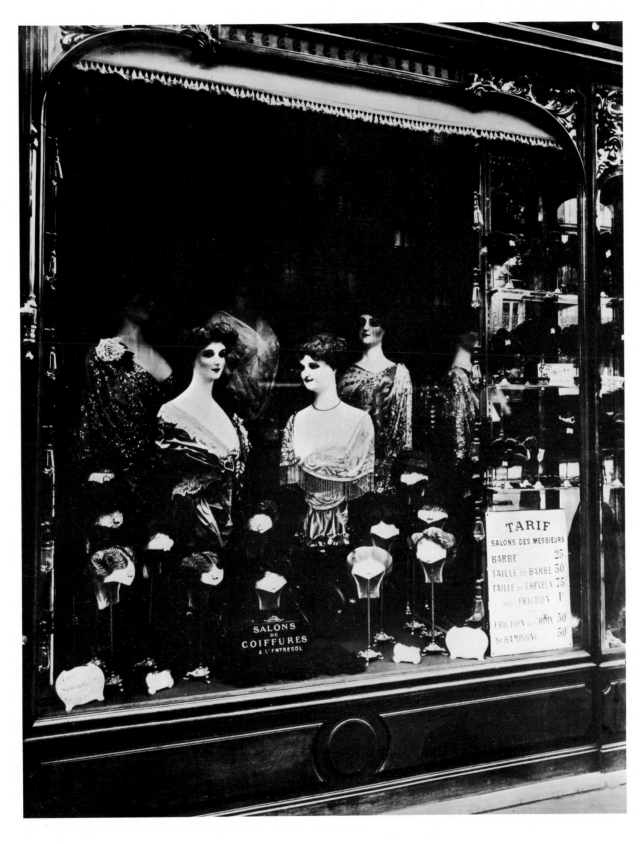

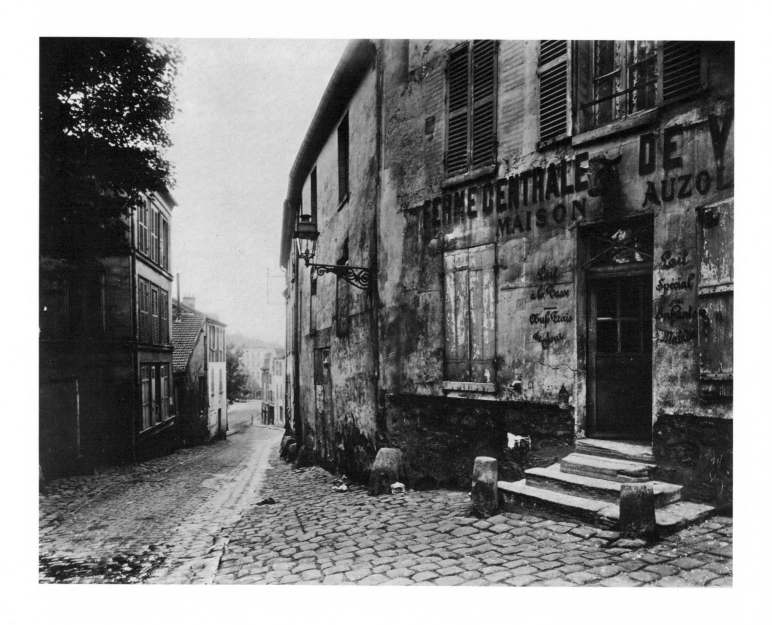

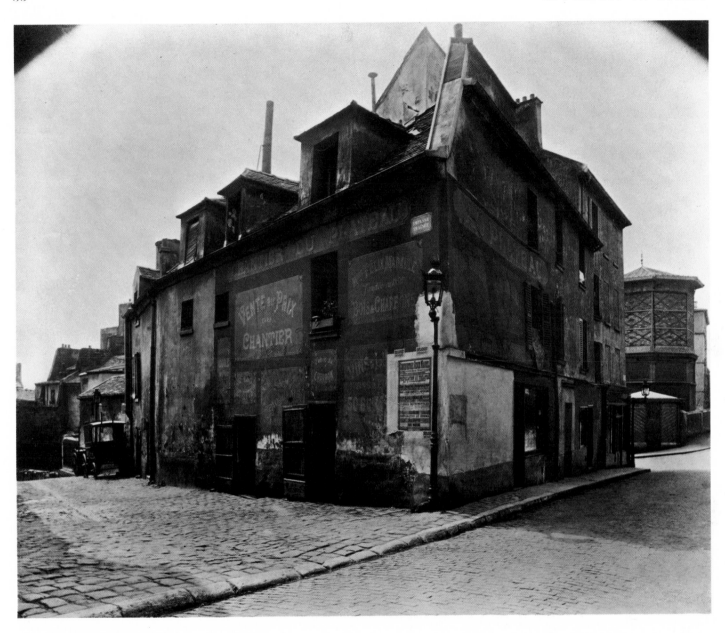

The loneliness and emptiness of those short streets . . .

It may be thought that my love of magic journeys by train ought to have prevented me from sharing Albertine's wonder at the motor-car which takes even the invalid wherever he wishes to go and destroys our conception—which I had held hitherto—of position in space as the individual

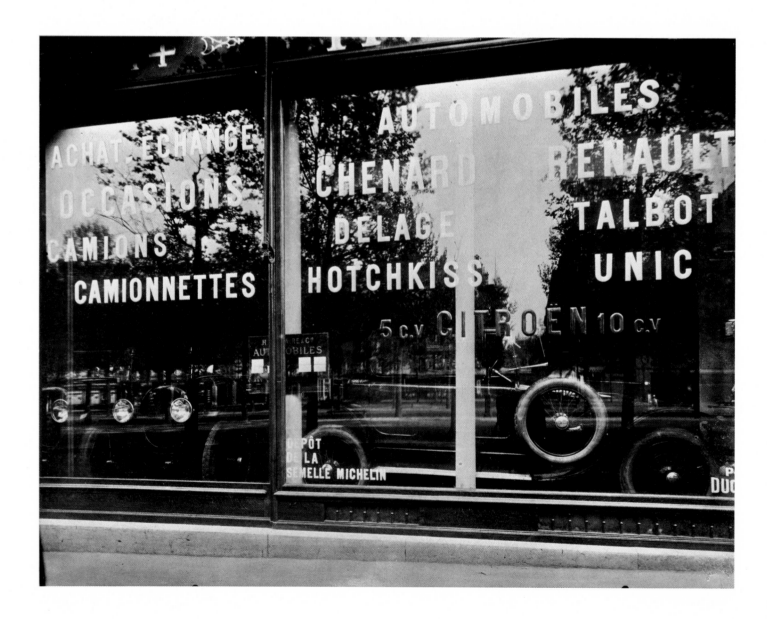

mark, the irreplaceable essence of irremovable beauties . . . it gives us on the contrary the impression of discovering, of determining for ourselves as with a compass, of helping us to feel with a more fondly exploring hand, with a finer precision, the true geometry, the fair measure of the earth.

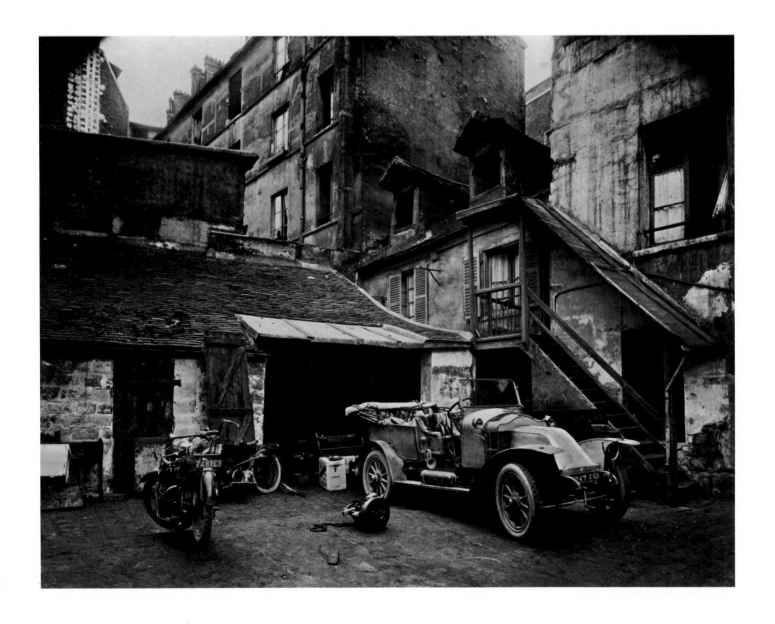

For a moment Robert imagined a Place Pigalle existence with unknown associates, sordid love affairs, afternoons spent in simple amusements, excursions or pleasure-parties, in that Paris in which the sunny brightness of the streets from the Boulevard de Clichy onwards did not seem the same as the solar radiance in which he himself strolled with his mistress, but must be something different, for love, and suffering which is one with love, have, like intoxication, the power to alter for us inanimate things. It was almost an unknown Paris in the heart of Paris itself . . .

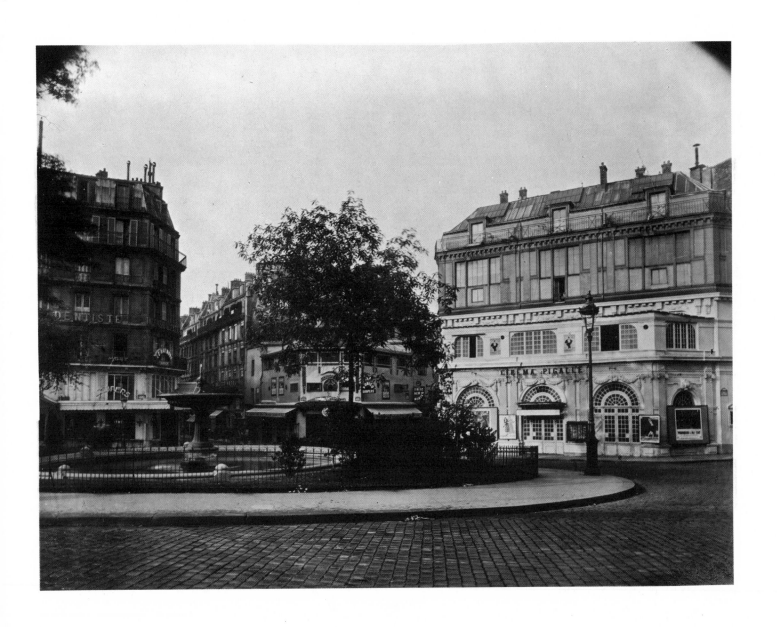

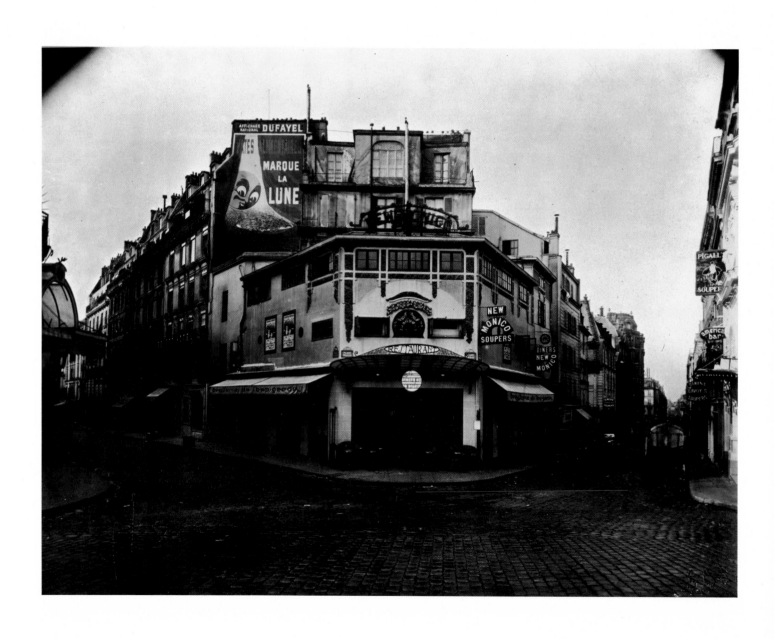

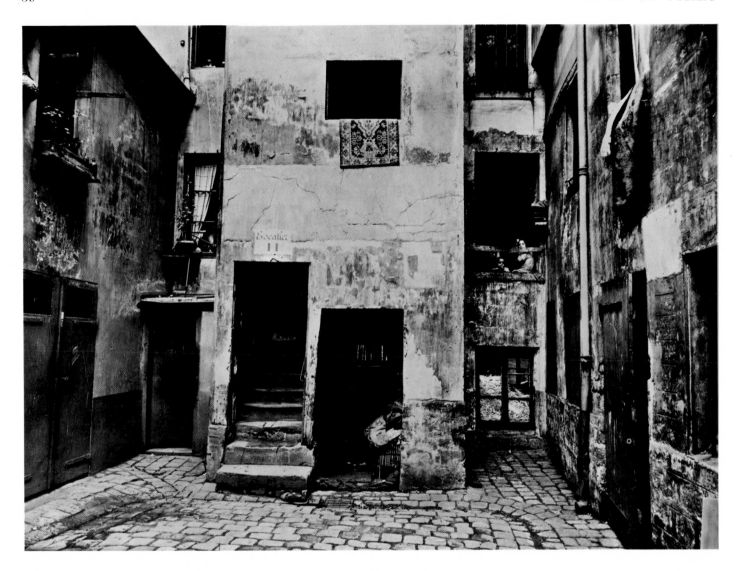

And then also, the extreme proximity of the houses, with their windows looking opposite one another on to a common courtyard, makes of each casement the frame in which a cook sits dreamily gazing down at the ground below, in which farther off a girl is having her hair combed by an old woman with the face, barely distinguishable in the shadow, of a witch: thus each courtyard provides for the adjoining house, by suppressing all sound in its interval, by leaving visible a series of silent gestures in a series of rectangular frames, glazed by the closing of the windows, an exhibition of a hundred Dutch paintings hung in rows.

. . . nothing but blocks of buildings of low elevation facing in every conceivable direction.

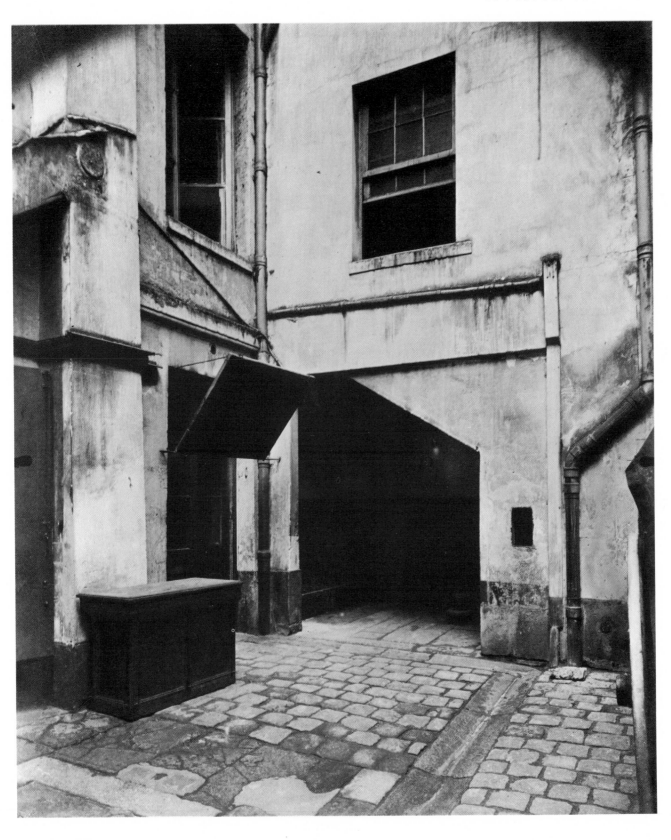

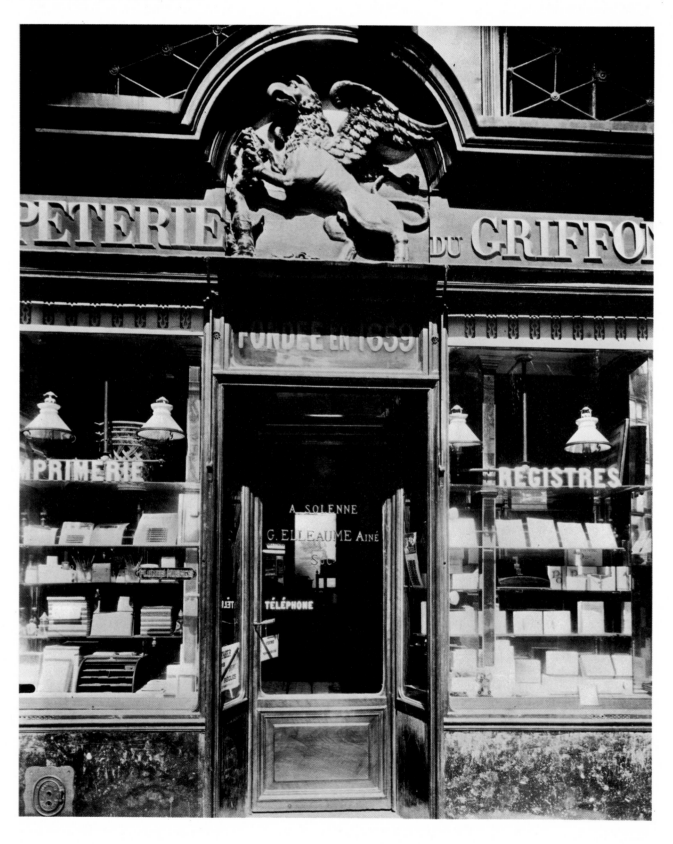

It is the magic charm of the old aristocratic quarters that they are at the same time plebeian.

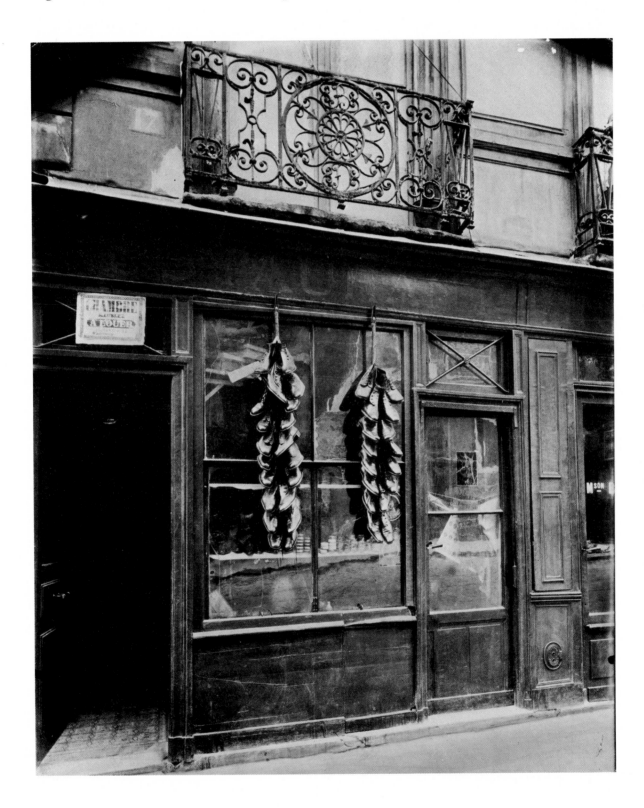

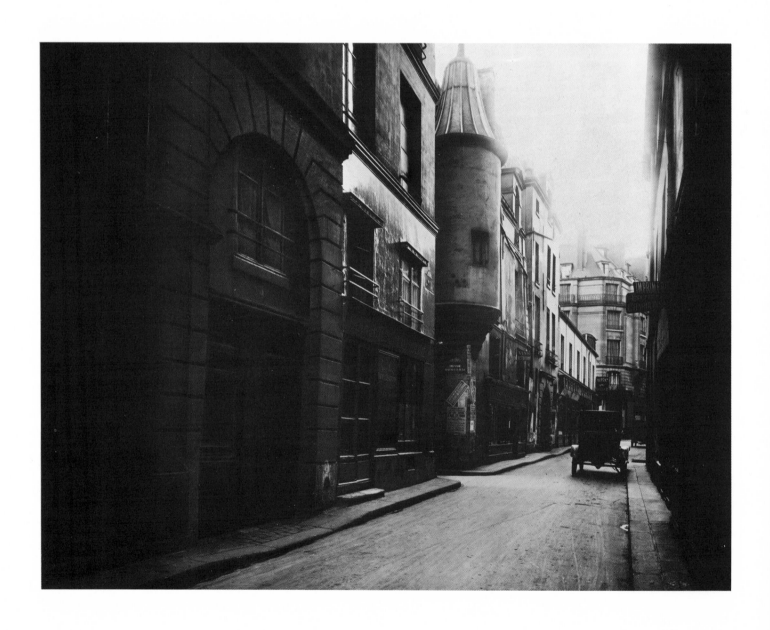

It was one of those old town houses, a few of which are perhaps still to be found, in which the court of honour—whether they were alluvial deposits washed there by the rising tide of democracy, or a legacy from a more primitive time when the different trades were clustered round the overlord—is flanked by little shops and workrooms, a shoemaker's, for instance, or a tailor's . . .

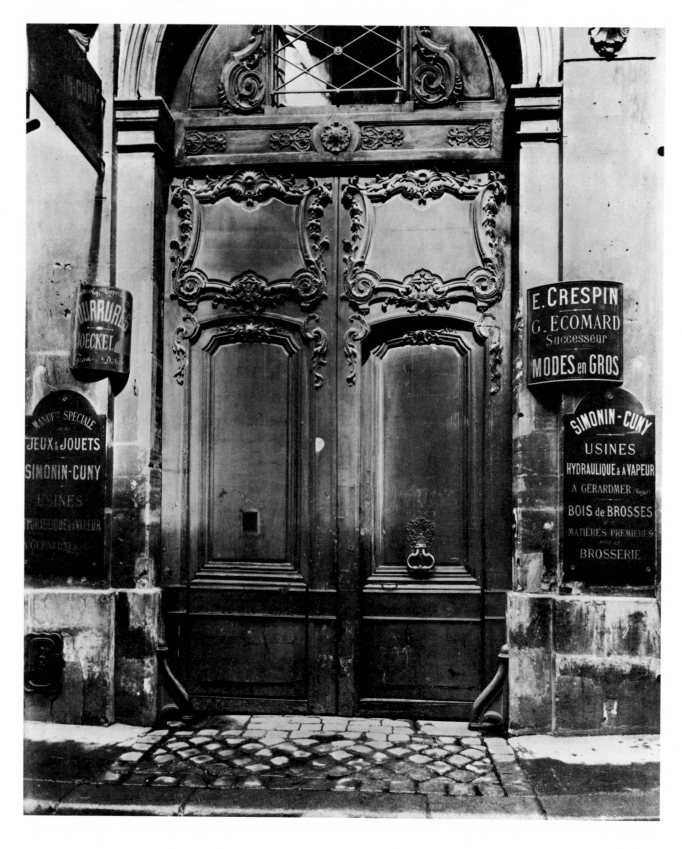

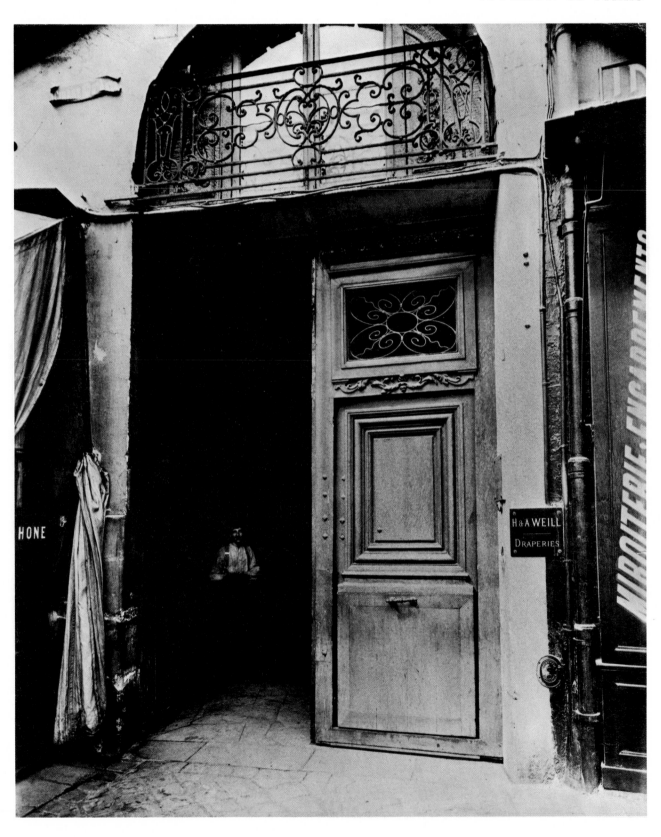

Just as, sometimes, cathedrals used to have them within a stone's throw of their porches (which have even preserved the name, like the porch of Rouen styled the Booksellers', because these latter used to expose their merchandise in the open air against its walls), so various minor trades, but peripatetic, used to pass in front of the noble Hôtel de Guermantes, and made one think at times of the ecclesiastical France of long ago.

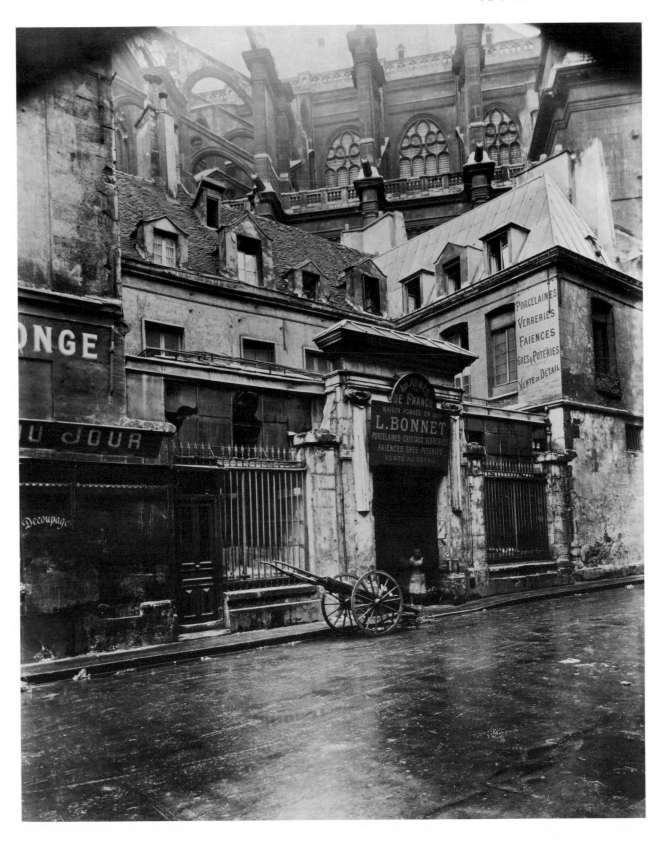

It is not only in Venice that one has those outlooks on to several houses at once which have proved so tempting to painters; it is just the same in Paris. Nor do I cite Venice at random. It is of its poorer quarters that certain poor quarters of Paris make one think, in the morning, with their tall, wide chimneys to which the sun imparts the most vivid pinks, the brightest reds; it is a whole garden that flowers above the houses, and flowers in such a variety of tints that one would call it, planted on top of the town, the garden of a tulip-fancier of Delft or Haarlem.

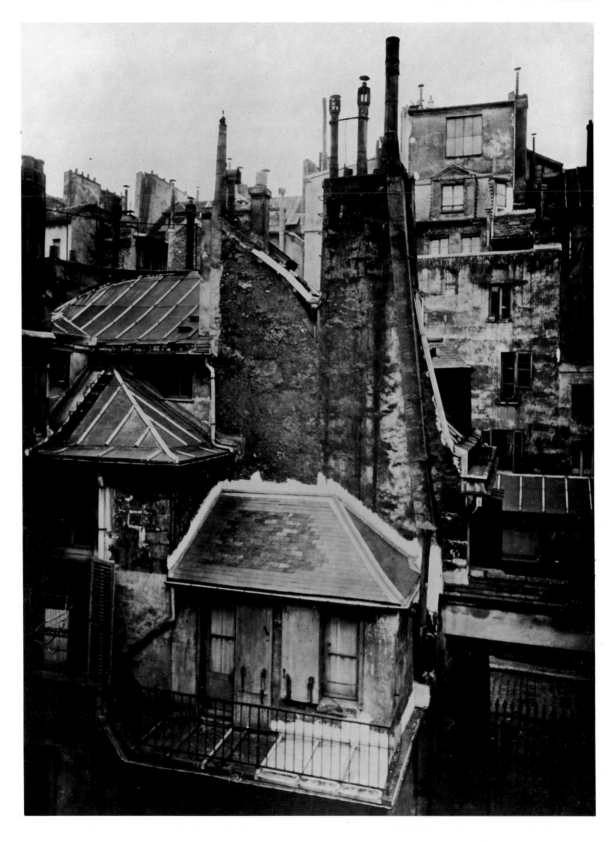

I proceeded on my way, and often, in the dark alley that ran past the cathedral, as long ago on the road to Méséglise, the force of my desire caught and held me; it seemed that a woman must be on the point of appearing, to satisfy it; if, in the darkness, I felt suddenly brush past me a skirt, the violence of the pleasure which I then felt made it impossible for me to believe that the contact was accidental and I attempted to seize in my arms a terrified stranger. This gothic alley meant for me something so real that if I had been successful in raising and enjoying a woman there, it would have been impossible for me not to believe that it was the ancient charm of the place that was bringing us together, and even though she were no more than a common street-walker, stationed there every evening, still the wintry night, the strange place, the darkness, the mediaeval atmosphere would have lent her their mysterious glamour.

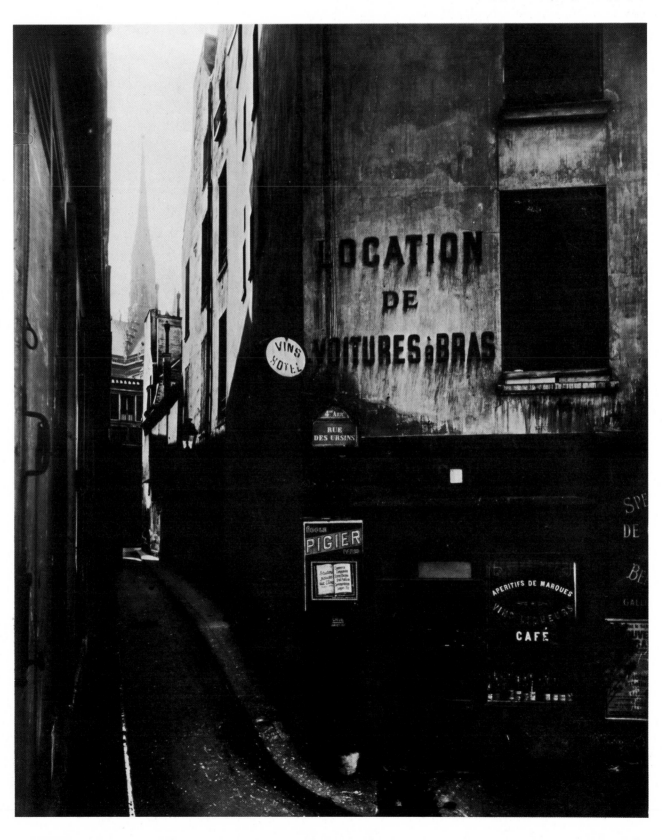

I imagined that the Seine, flowing through the hoops formed by the bridges and the reflexion of their arches in the water, must resemble the Bosporus.

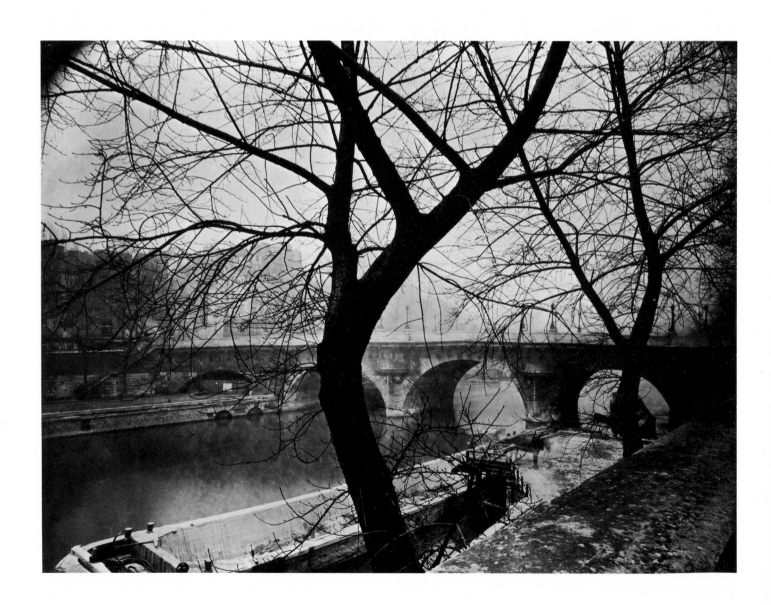

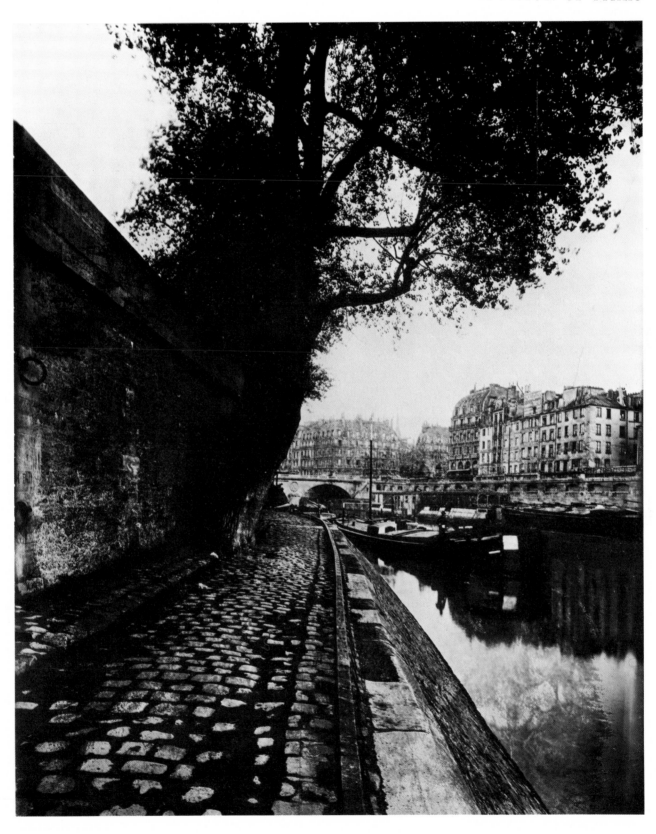

The Peopled Streets

The emotion that I felt grip me when I caught sight of a wine-merchant's girl at her desk or a laundress chatting in the street was the emotion that we feel on recognising a goddess. Now that Olympus no longer exists, its inhabitants dwell upon the earth. And when, in composing a mythological scene, painters have engaged to pose as Venus or Ceres young women of humble birth, who follow the most sordid callings, so far from committing sacrilege, they have merely added, restored to them, the quality, the various attributes which they had forfeited.

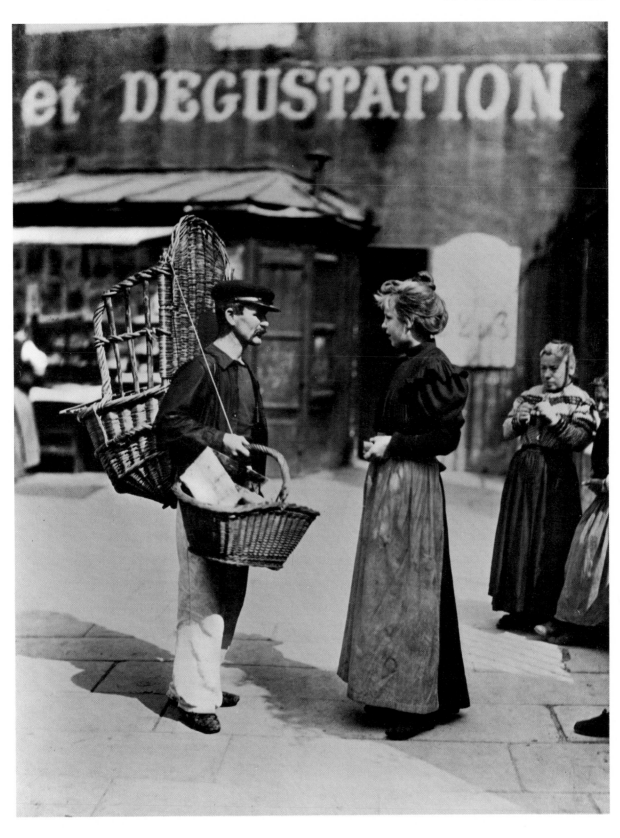

If, on rising from my bed, I went to the window and drew the curtain aside for a moment, it was not merely, as a pianist for a moment turns back the lid of his instrument, to ascertain whether, on the balcony and in the street, the sunlight was tuned to exactly the same pitch as in my memory, it was also to catch a glimpse of some laundress carrying her linen-basket, a bread-seller in her blue apron, a dairymaid in her tucker and sleeves of white linen, carrying the yoke from which her jugs of milk are suspended, some haughty golden-haired miss escorted by a governess, a composite image, in short, which the differences of outline, numerically perhaps insignificant, were enough to make as different from any other as, in a phrase of music, the difference between two notes, an image but for the vision of which I should have impoverished my day of the objects which it might have to offer to my desires of happiness.

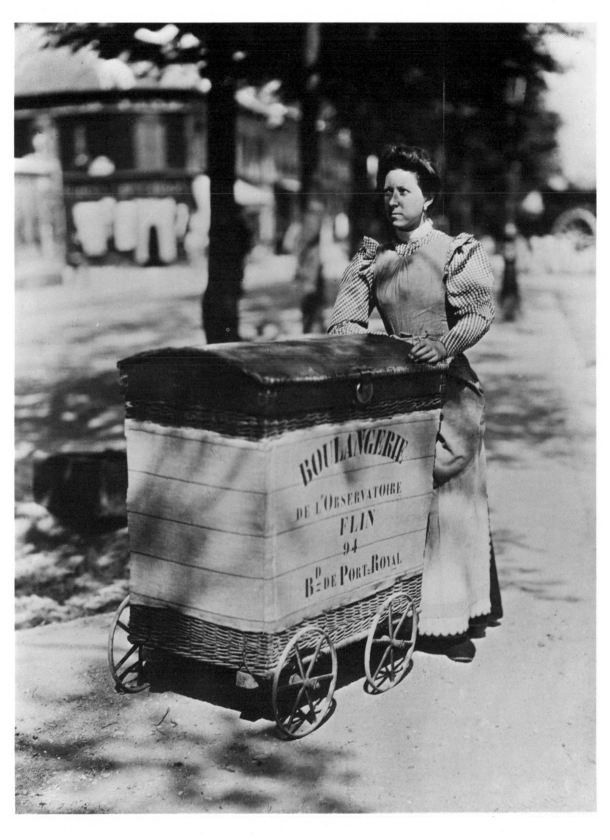

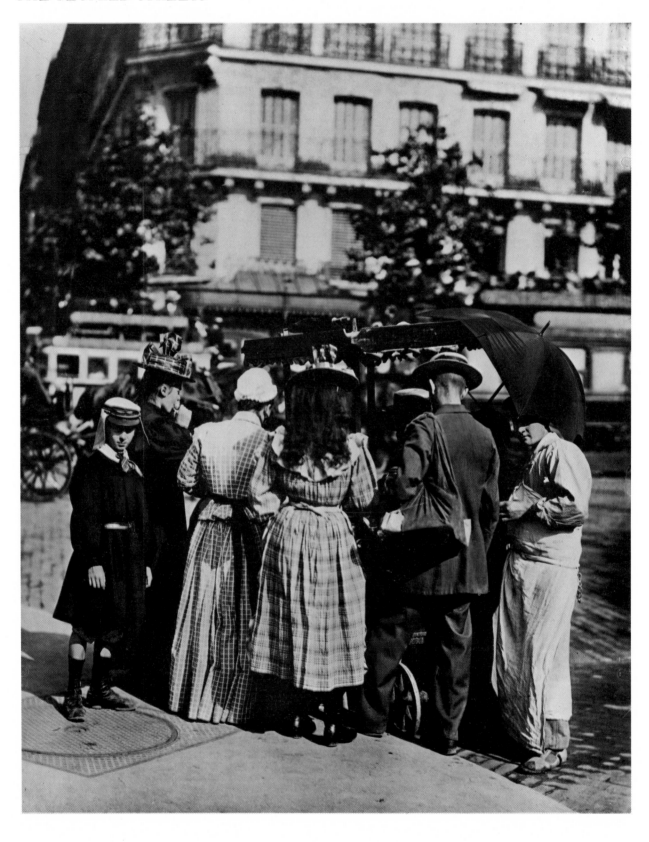

Several of the foodstuffs cried in the street, which personally I detested, were greatly to Albertine's liking, so much so that Françoise used to send her young footman out to buy them, slightly humiliated perhaps at finding himself mingled with the plebeian crowd. Very distinct in this peaceful quarter (where the noise was no longer a cause of lamentation to Françoise and had become a source of pleasure to myself), there came to me, each with its different modulation, recitatives declaimed by those humble folk as they would be in the music—so entirely popular—of *Boris*, where an initial intonation is barely altered by the inflexion of one note which rests upon another, the music of the crowd which is more a language than a music. It was *ah! le bigorneau, deux sous le bigorneau,* which brought people running to the cornets in which were sold those horrid little shellfish, which, if Albertine had not been there, would have disgusted me, just as the snails disgusted me which I heard cried for sale at the same hour. Here again it was of the barely lyrical declamation of Moussorgsky that the vendor reminded me, but not of it alone. For after having almost 'spoken': *Les escargots, ils sont frais, ils sont beaux,* it was with the vague melancholy of Maeterlinck, transposed into music by Debussy, that the snail vendor, in one of those pathetic finales in which the composer of *Pelléas* shews his kinship with Rameau: "If vanquished I must be, is it for thee to be my vanquisher?" added with a singsong melancholy: *On les vend six sous la douzaine . . .*

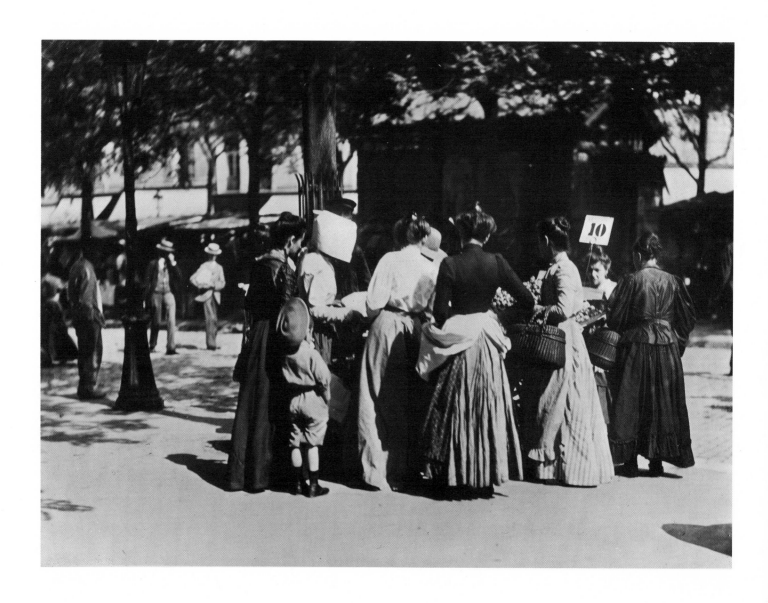

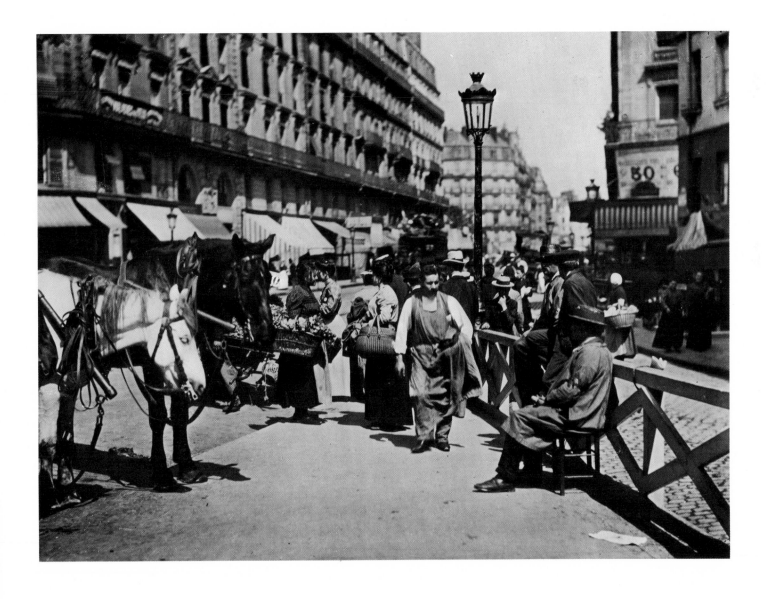

On our way home Françoise made me stop at the corner of the Rue Royale, before an open-air stall from which she selected for her own stock of presents photographs of Pius IX and Raspail, while for myself I purchased one of Berma.

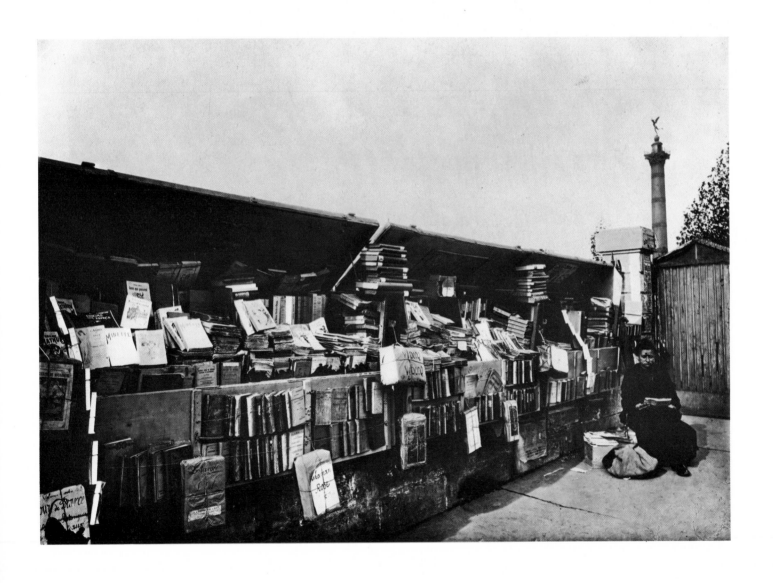

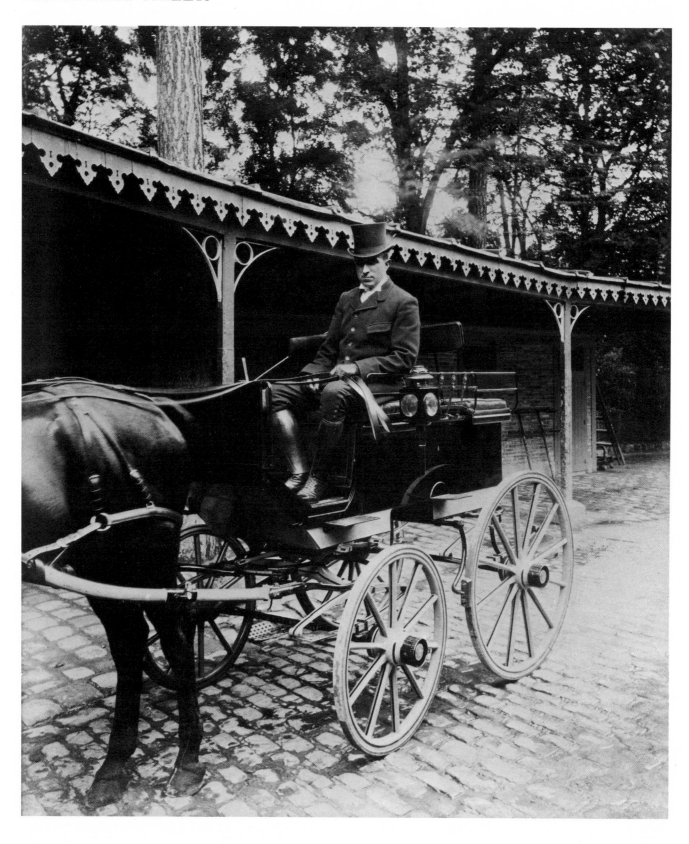

On alighting from his carriage, in the foreground of that fictitious summary of their domestic existence which hostesses are pleased to offer to their guests on ceremonial occasions, and in which they shew a great regard for accuracy of costume and setting, Swann was amused to discover the heirs and successors of Balzac's 'tigers'—now 'grooms'—who normally followed their mistress when she walked abroad, but now, hatted and booted, were posted out of doors, in front of the house on the gravelled drive, or outside the stables, as gardeners might be drawn up for inspection at the ends of their several flower-beds.

. . . the Duke . . . made one of his grooms lead past . . . some horse that he had just been buying.

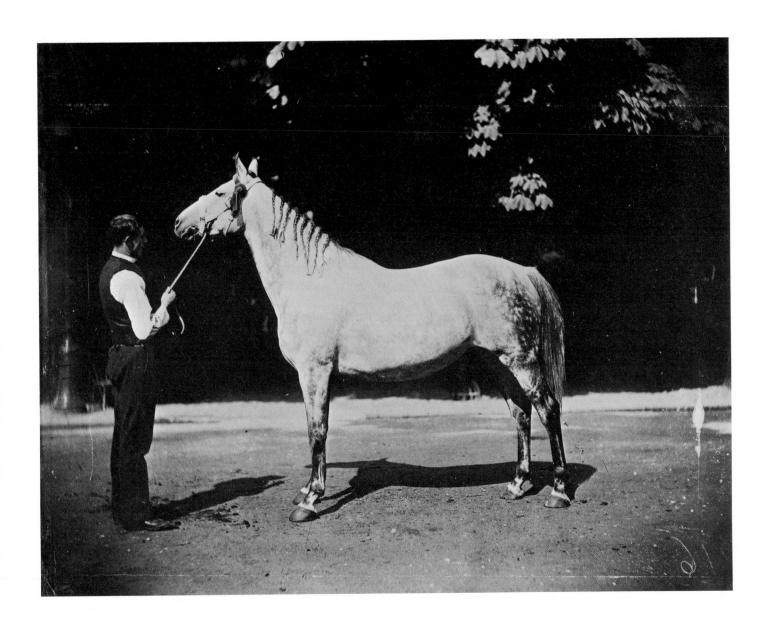

. . . the bawd, hardly less ancient, venerable and moss-grown, standing outside her ill-famed door.

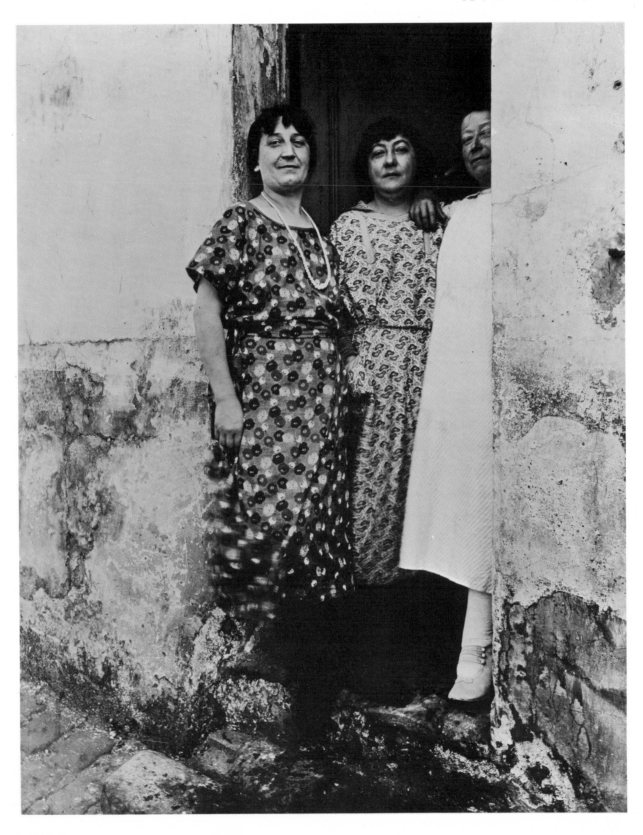

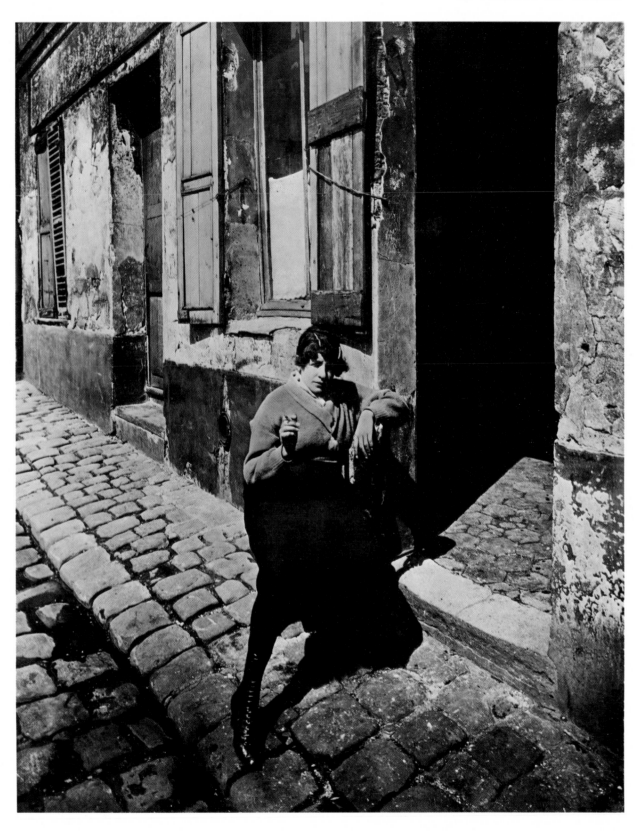

"Poor children," Françoise would exclaim, in tears almost before she had reached the railings; "poor boys, to be mown down like grass in a meadow. It's just shocking to think of," she would go on, laying a hand over her heart, where presumably she had felt the shock.

"A fine sight, isn't it, Mme Françoise, all these young fellows not caring two straws for their lives?" The gardener would ask, just to 'draw' her. And he would not have spoken in vain.

"Not caring for their lives, is it? Why, what in the world is there that we should care for if it's not our lives, the only gift the Lord never offers us a second time? Oh dear, oh dear; you're right all the same; it's quite true, they don't care! I can remember them in '70; in those wretched wars they've no fear of death left in them; and then they aren't worth the price of a rope to hang them with; they're not men any more, they're lions." For by her way of thinking, to compare a man with a lion, which she used to pronounce 'lie-on,' was not at all complimentary to the man.

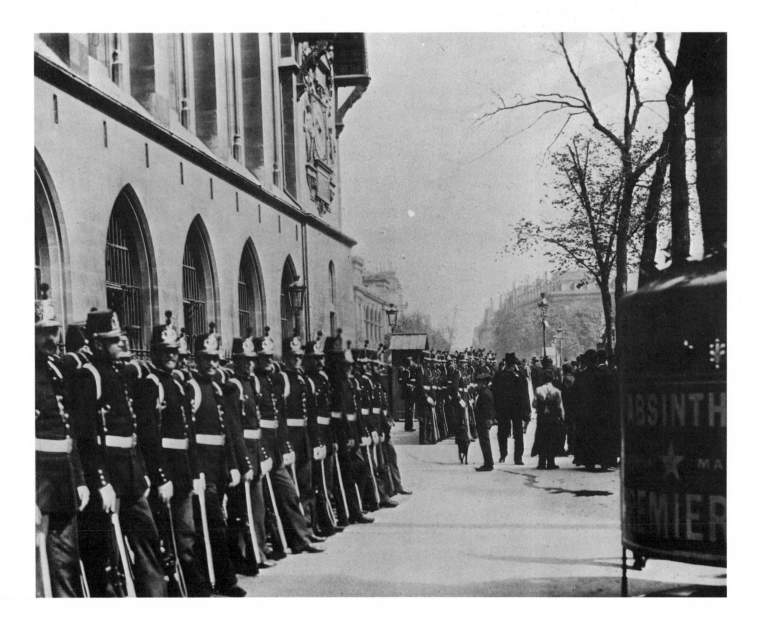

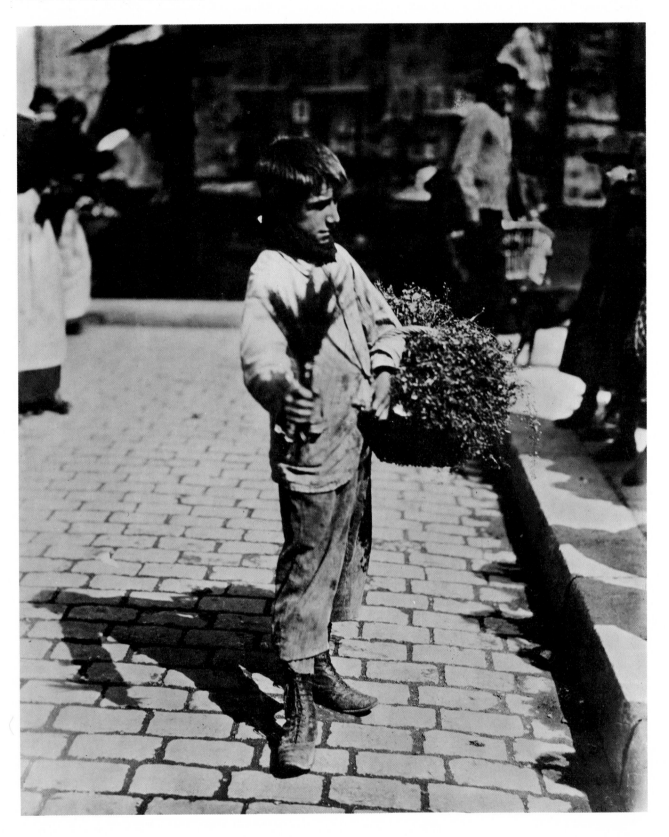

There was at first a silence, amid which the whistle of the tripe vendor and the horn of the tramcar made the air ring in different octaves, like a blind piano-tuner. Then gradually the interwoven motives became distinct, and others were combined with them. There was also a new whistle, the call of a vendor the nature of whose wares I have never discovered, a whistle that was itself exactly like the scream of the tramway, and, as it was not carried out of earshot by its own velocity, one thought of a single car, not endowed with motion, or broken down, immobilized, screaming at short intervals like a dying animal.

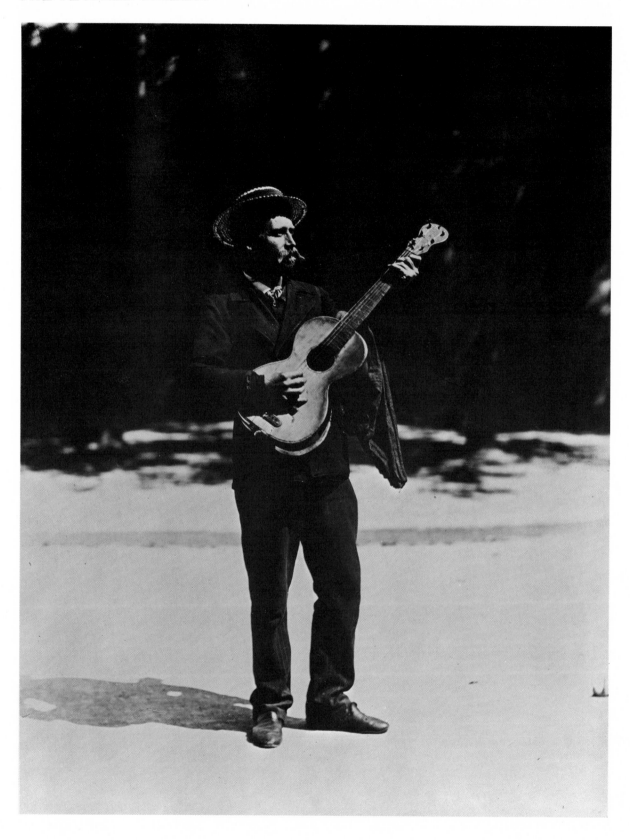

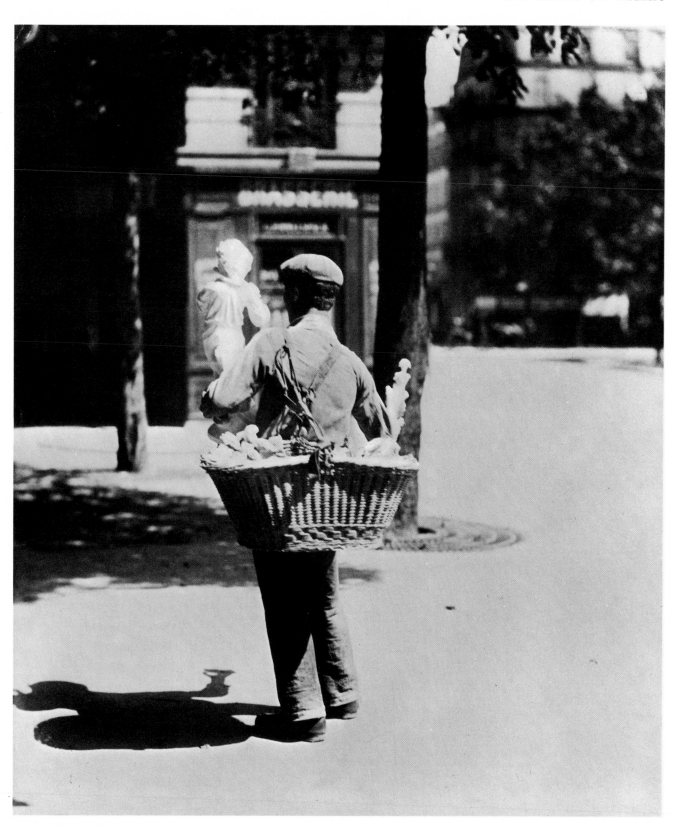

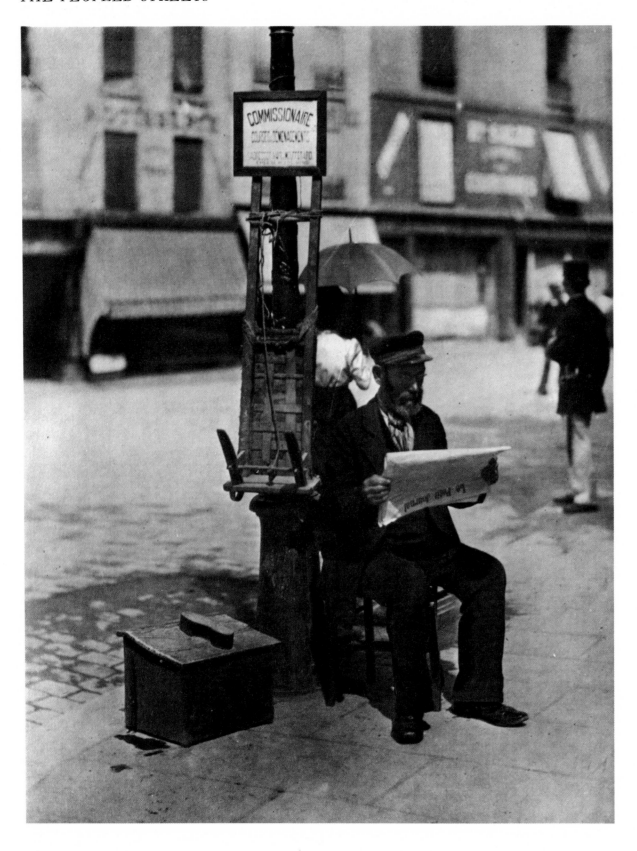

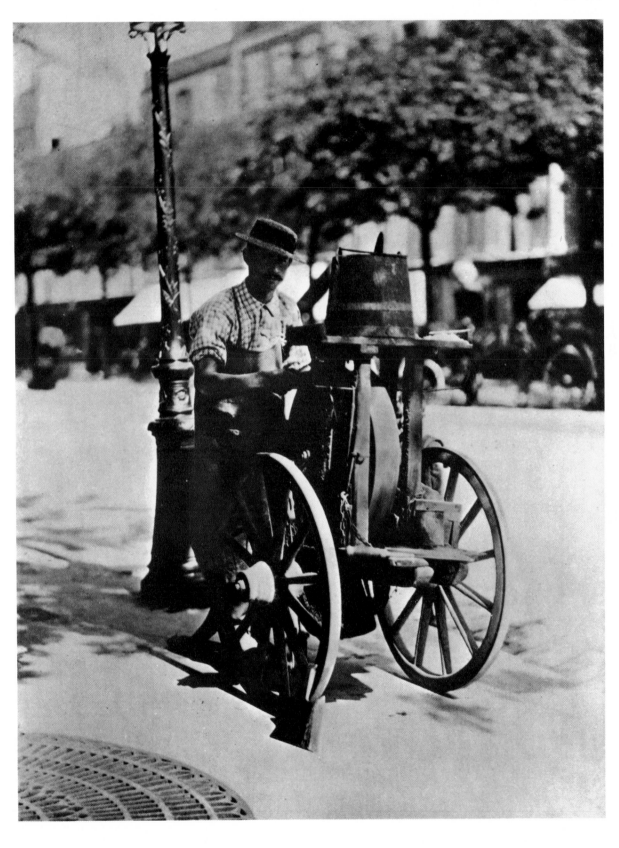

It was true that the fantasy, the spirit of each vendor or vendress frequently introduced variations into the words of all these chants that I used to hear from my bed. And yet a ritual suspension interposing a silence in the middle of a word, especially when it was repeated a second time, constantly reminded me of some old church.

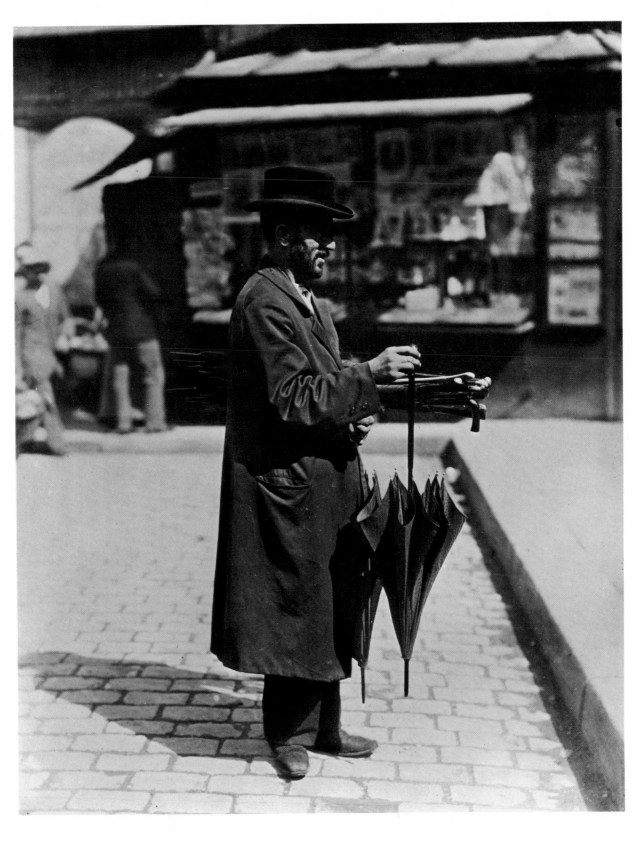

One of the fountains was filled with a ruddy glow, while in the other the moonlight had already begun to turn the water opalescent. Between them were children at play, uttering shrill cries, wheeling in circles, obeying some necessity of the hour, like swifts or bats.

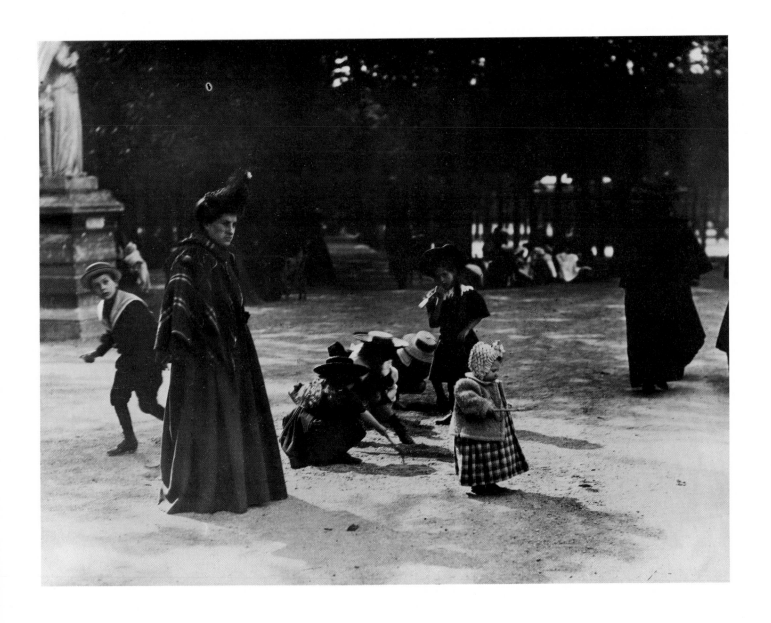

I stopped my carriage and was going to get out and walk about a bit, when my attention was caught by the sight of another carriage . . . In it a man with staring eyes and bent shoulders was sitting, or, rather, was placed and was making a great effort to sit up straight, like a child who has been told to behave properly.

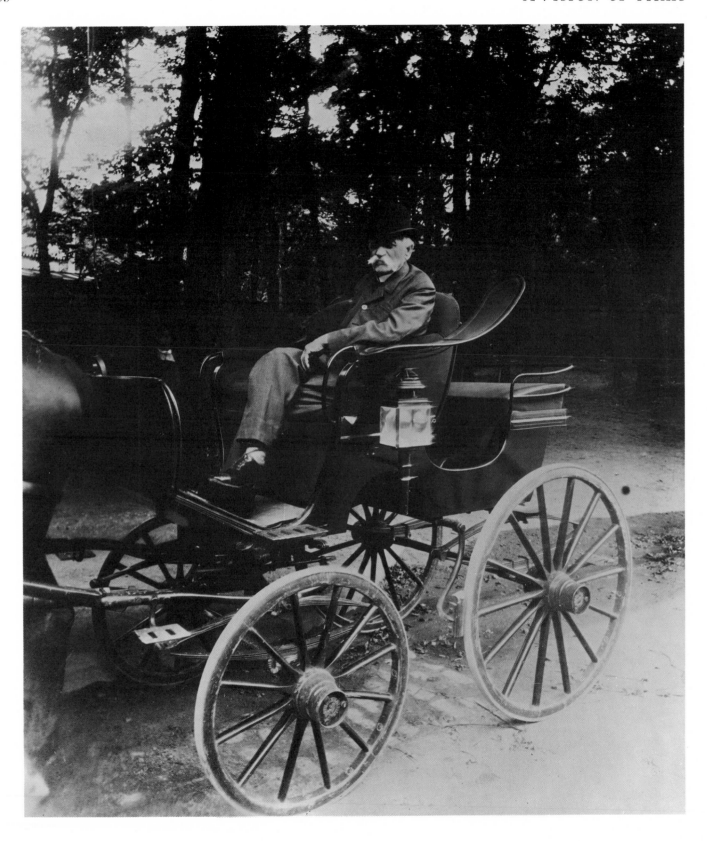

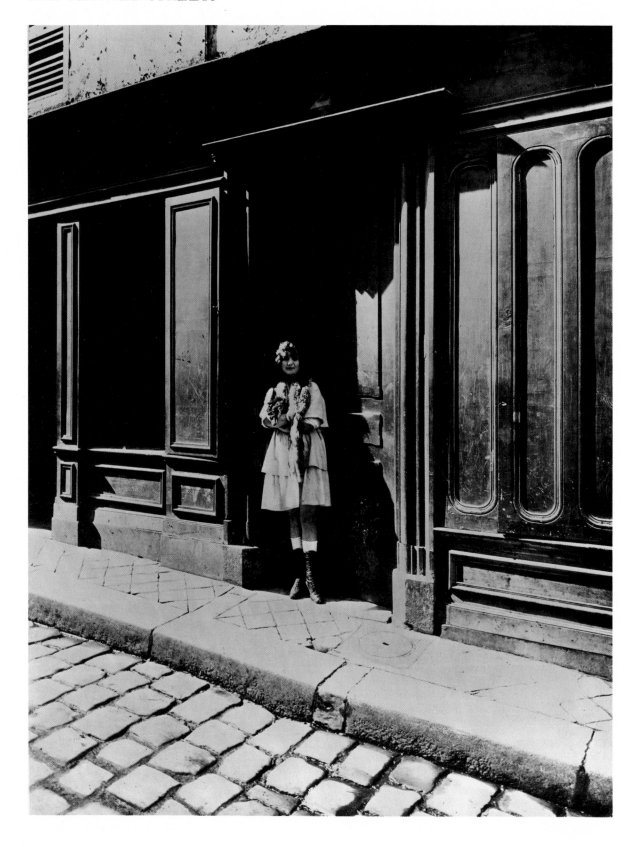

I saw that what had appeared to me to be not worth twenty francs when it had been offered to me for twenty francs in the house of ill fame, where it was then for me simply a woman desirous of earning twenty francs, might be worth more than a million, more than one's family, more than all the most coveted positions in life if one had begun by imagining her to embody a strange creature, interesting to know, difficult to seize and to hold.

This crowd gave me just about as much pleasure as a photograph of it in one of the 'illustrateds' might give a patient who was turning its pages in the surgeon's waiting-room. I was astonished to find that there were people so different from myself that this stroll through the town had actually been recommended to me by the manager as a distraction, and also that the torture chamber

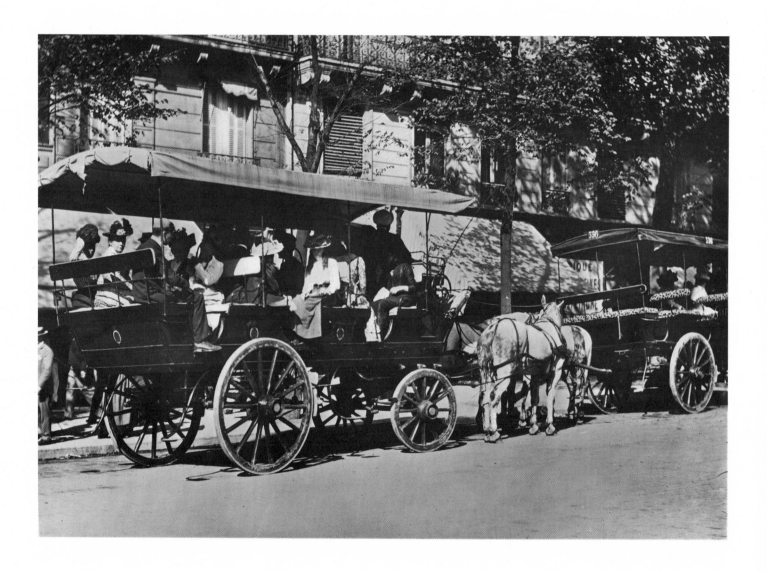

which a new place of residence is could appear to some people a 'continuous amusement,' to quote the hotel prospectus, which might, it was true, exaggerate, but was, for all that, addressed to a whole army of clients to whose tastes it must appeal.

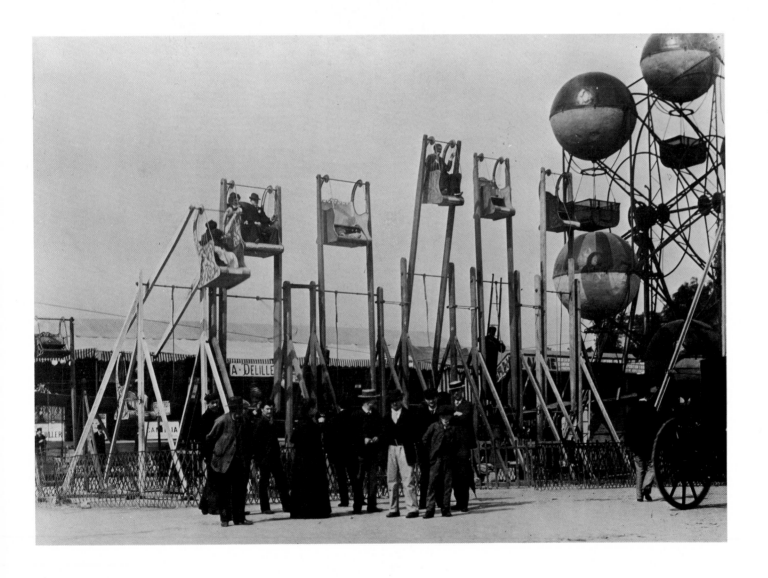

It was the season when, early in the morning, pupils and teachers resort to the public gardens to prepare for the final examinations under the trees, seeking to extract the sole drop of coolness that is let fall by a sky less ardent than in the midday heat but already as sterilely pure.

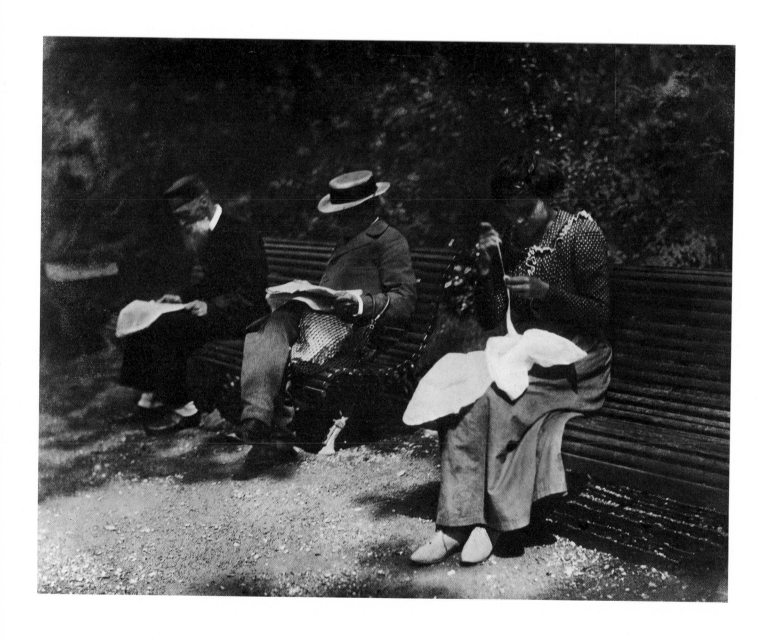

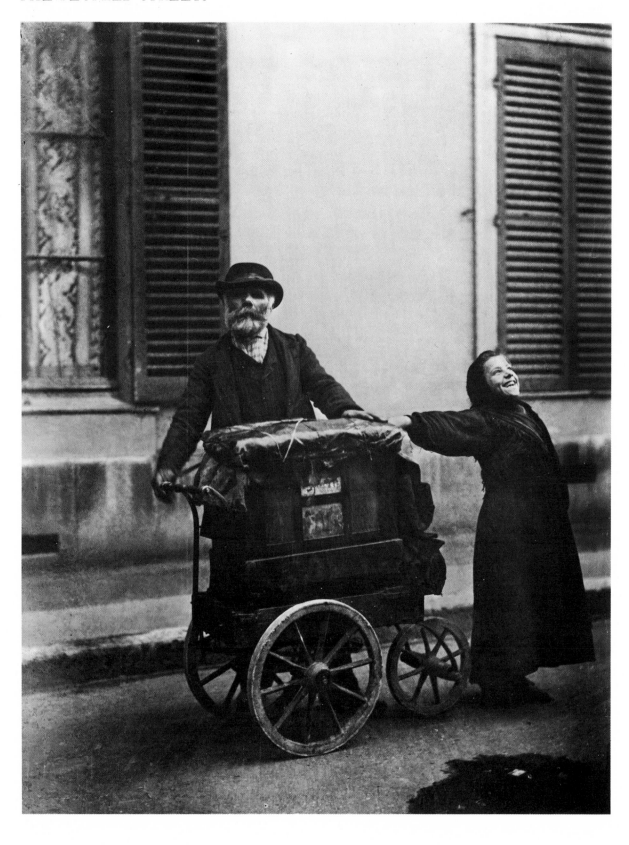

I had been apprised . . . by hearing a barrel-organ playing, beneath the window, *En revenant de la revue,* that the winter had received, until nightfall, an unexpected, radiant visit from a day of spring.

The Inward Space

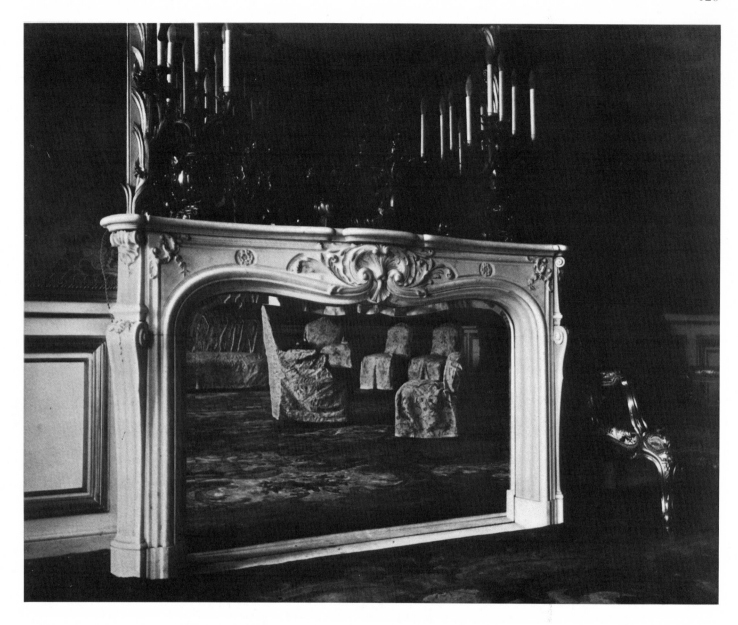

In short, the idea of a lodging, of simply a case for our existence from day to day which shields us only from the cold and from being overlooked by other people, was absolutely inapplicable to this house, an assembly of rooms as real as a colony of people, living, it was true, in silence, but things which one was obliged to meet, to avoid, to appreciate, as one came in. One tried not to disturb them, and one could not look without respect at the great drawing-room which had formed . . . the habit of stretching itself at its ease, among its hangings of old gold and beneath the clouds of its painted ceiling.

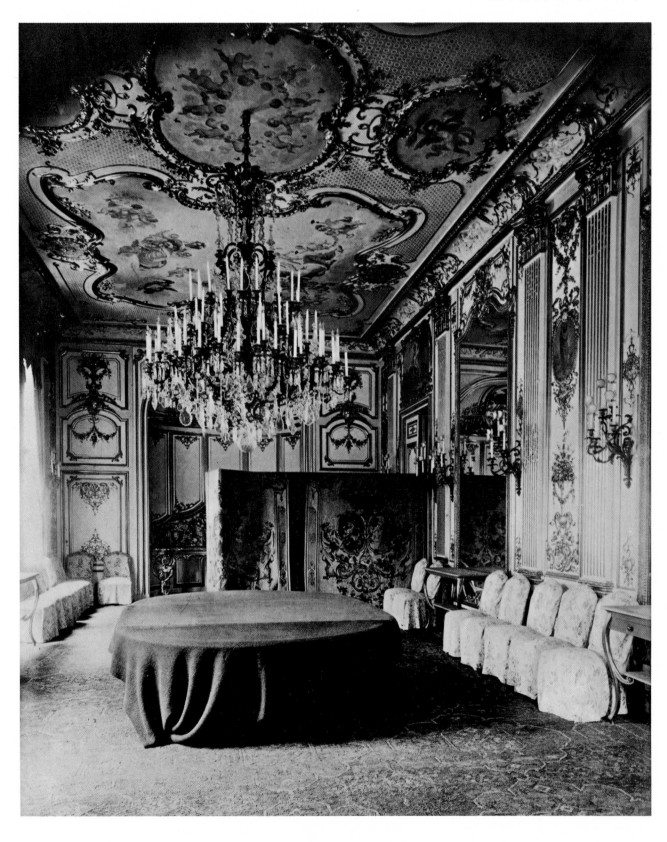

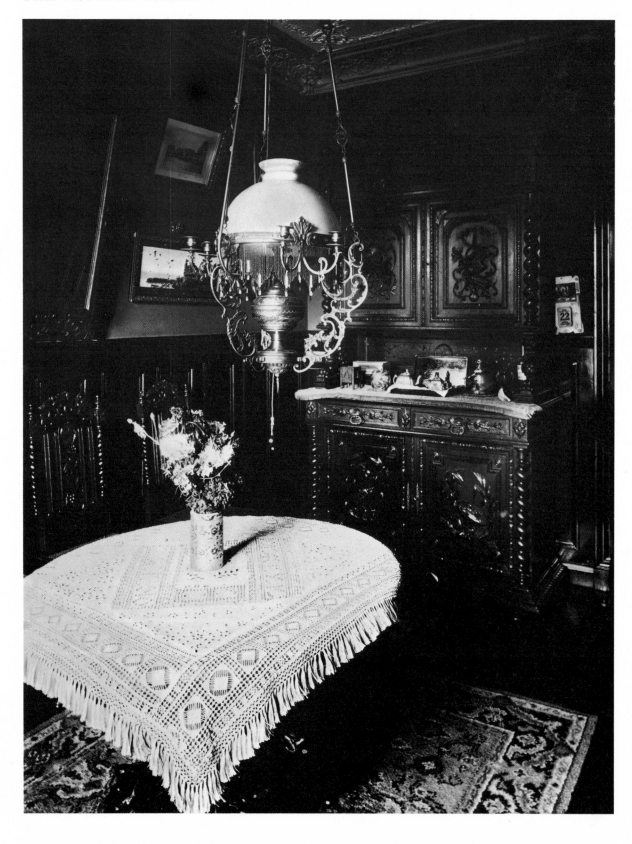

My aunt's life was now practically confined to two adjoining rooms, in one of which she would rest in the afternoon while they aired the other.

They were rooms of that country order which (just as in certain climes whole tracts of air or ocean are illuminated or scented by myriads of protozoa which we cannot see) fascinate our sense of smell with the countless odours springing from their own special virtues, wisdom, habits, a whole secret system of life, invisible, superabundant and profoundly moral, which their atmosphere holds in solution.

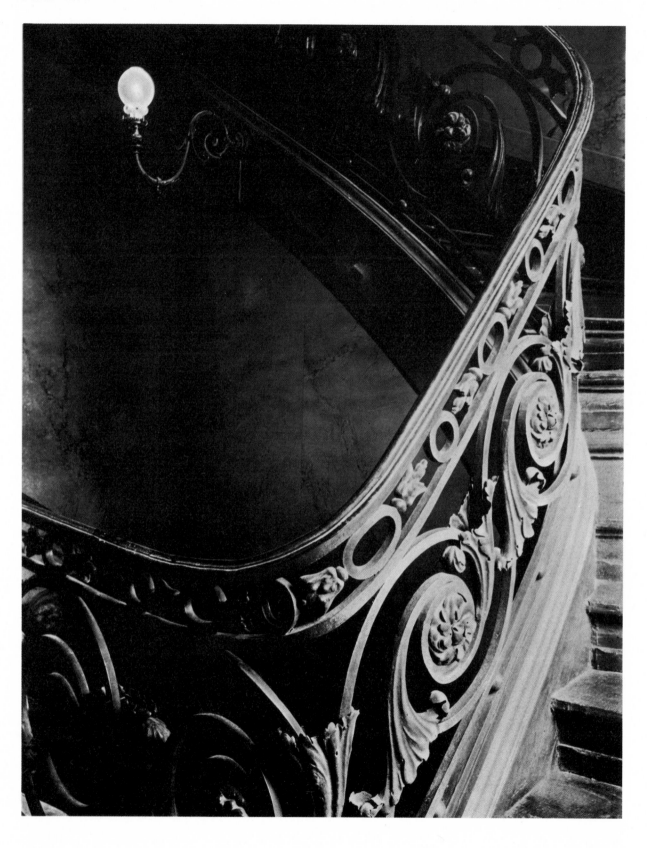

The fact of the matter was that there remained of the old palace a superfluous refinement of structure and decoration, out of place in a modern hotel, which, released from the service of any practical purpose, had in its long spell of leisure acquired a sort of life . . .

. . . lobbies as long as corridors and as ornate as drawing-rooms, which had the air rather of being dwellers there themselves than of forming part of a dwelling.

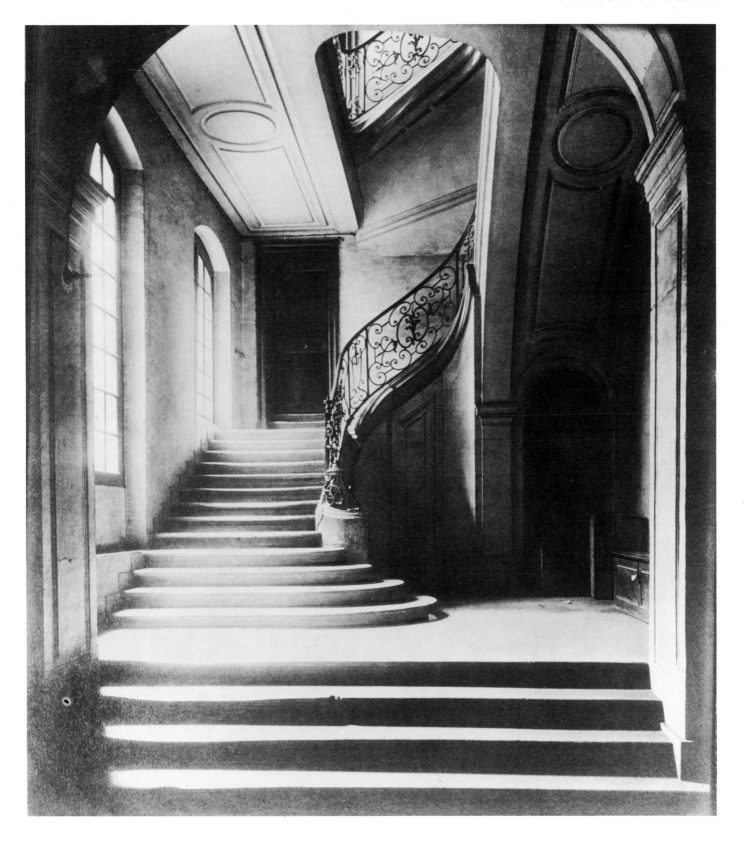

If I wished to go out or to come in without taking the lift or being seen from the main staircase, a smaller private staircase, no longer in use, offered me its steps so skilfully arranged, one close above another, that there seemed to exist in their gradation a perfect proportion of the same kind as those which, in colours, scents, savours, often arouse in us a peculiar, sensuous pleasure.

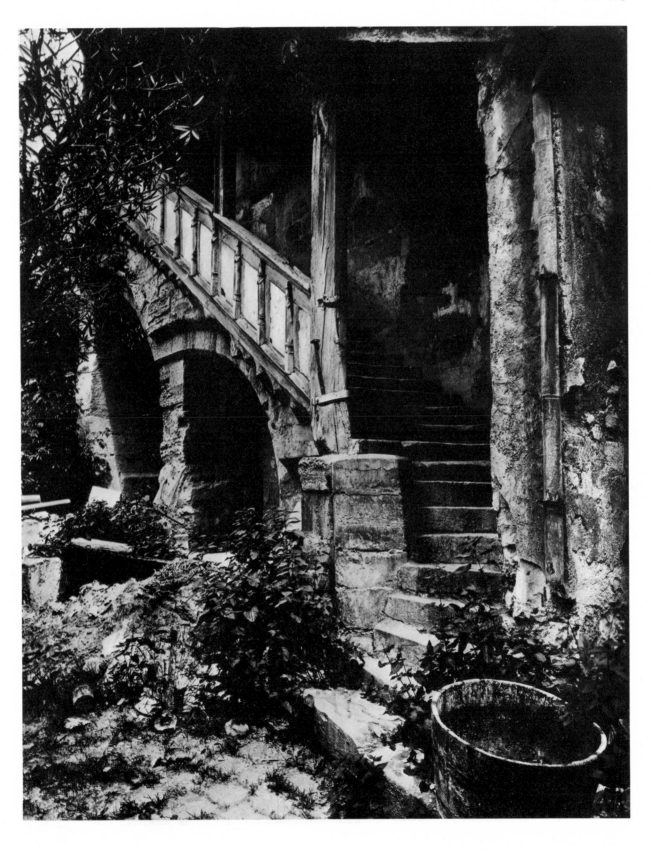

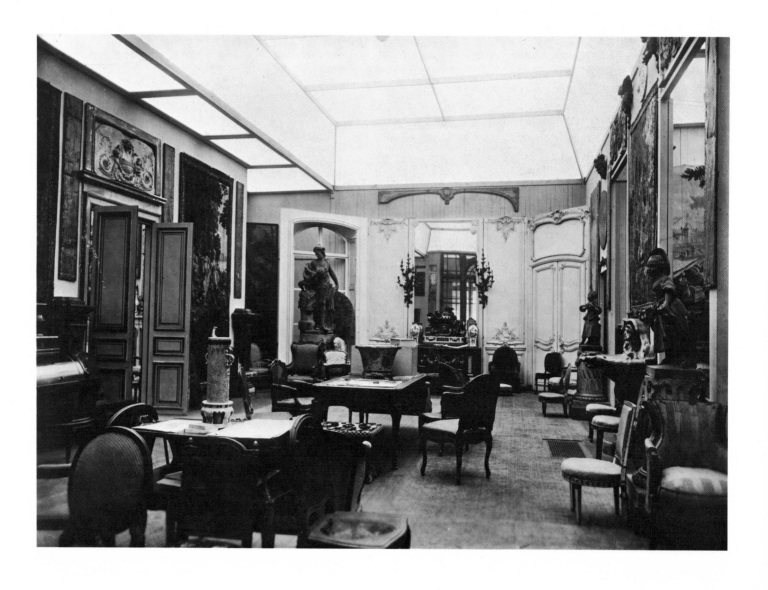

. . . always when I think of that drawing-room which Swann (not that the criticism implied on his part any intention to find fault with his wife's taste) found so incongruous—because, while it was still planned and carried out in the style, half conservatory, half studio, which had been that of the rooms in which he had first known Odette, she had, none the less, begun to replace in its medley a quantity of the Chinese ornaments, which she now felt to be rather gimcrack, a trifle dowdy, by a swarm of little chairs and stools and things upholstered in old Louis XIV silks . . .

". . . I'm going to say something that's not quite proper . . . but he has a bedroom, and more especially a bed in it, in which I should love to sleep—without him! . . ."

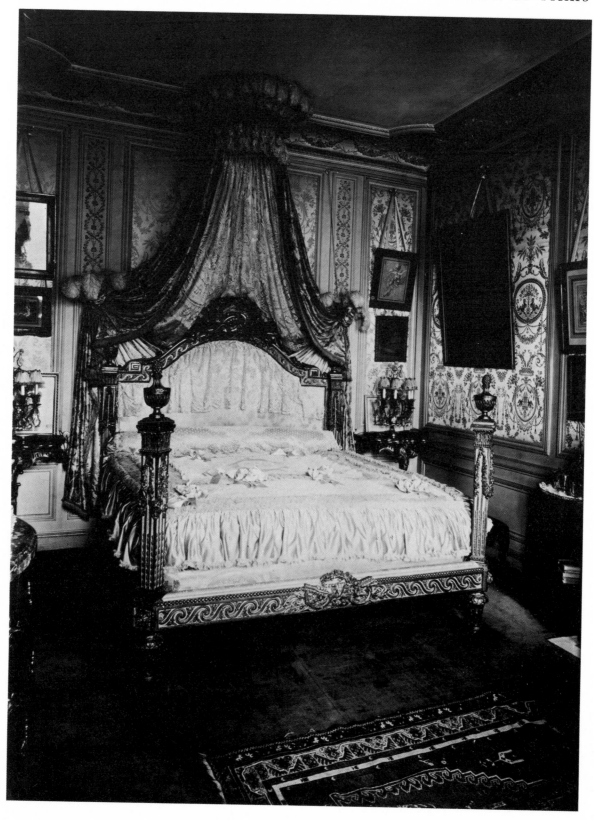

. . . and the admirable armchairs upholstered in Beauvais tapestry stood out with the almost purple redness of ripe raspberries.

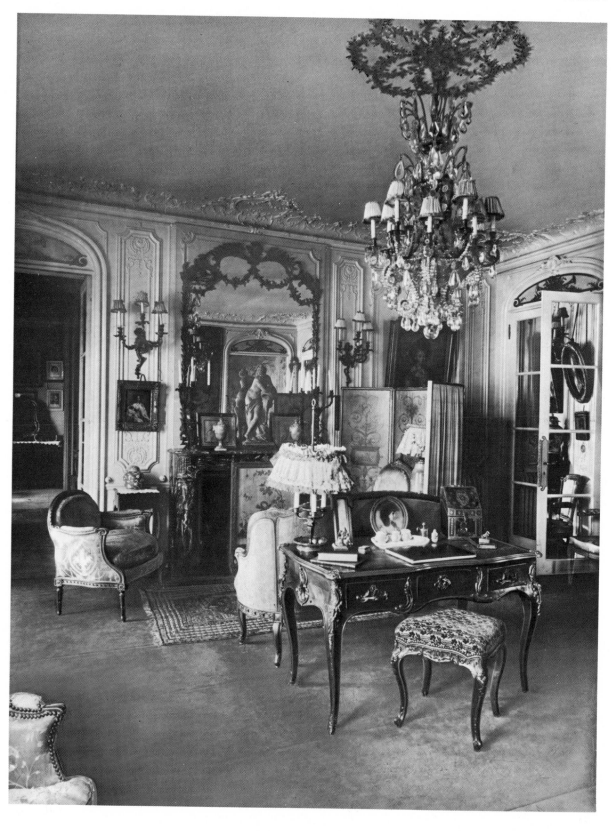

But ugly and expensive things are of great use, for they enjoy, among people who do not understand us, who have not our taste and with whom we cannot fall in love, a prestige that would not be shared by some proud object that does not reveal its beauty.

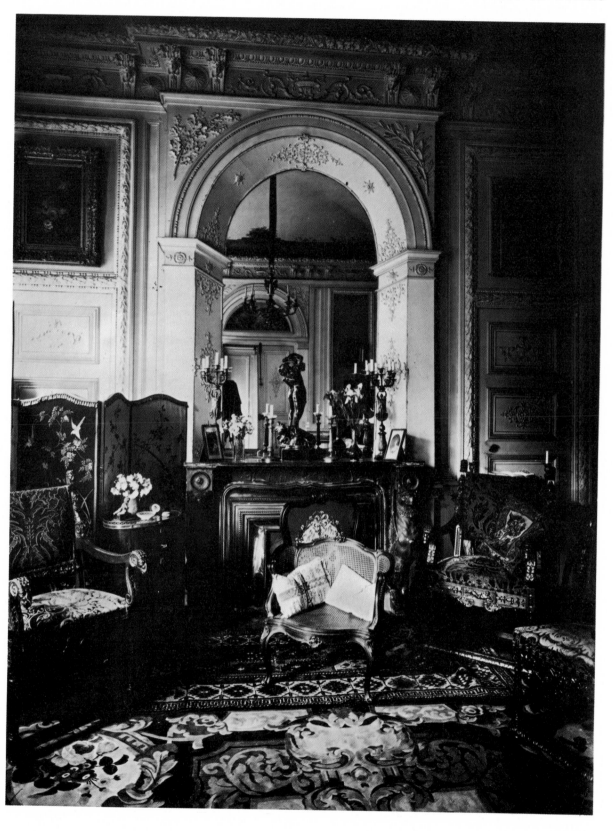

The Dimensions of Art

When I mentioned to Françoise a church in Milan—a city she would probably never visit—or the Cathedral of Reims, or even that of Arras; which she could not see because they had been more or less destroyed, she would envy the rich, who can treat themselves to the sight of such treasures, and would exclaim, with regretful longing: "Ah, how beautiful that must have been!"

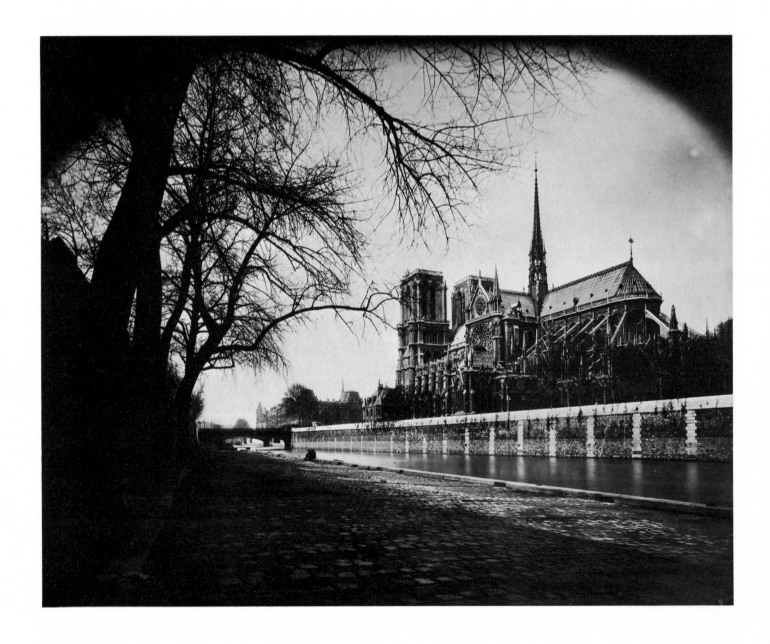

And yet, in all the years she had been living in Paris, she had never had the curiosity to go to see Notre-Dame. That was just because Notre-Dame was part of Paris, of the city in which her daily life unfolded itself and in which, consequently, it was difficult for our old servant to place the objects of her dreams . . .

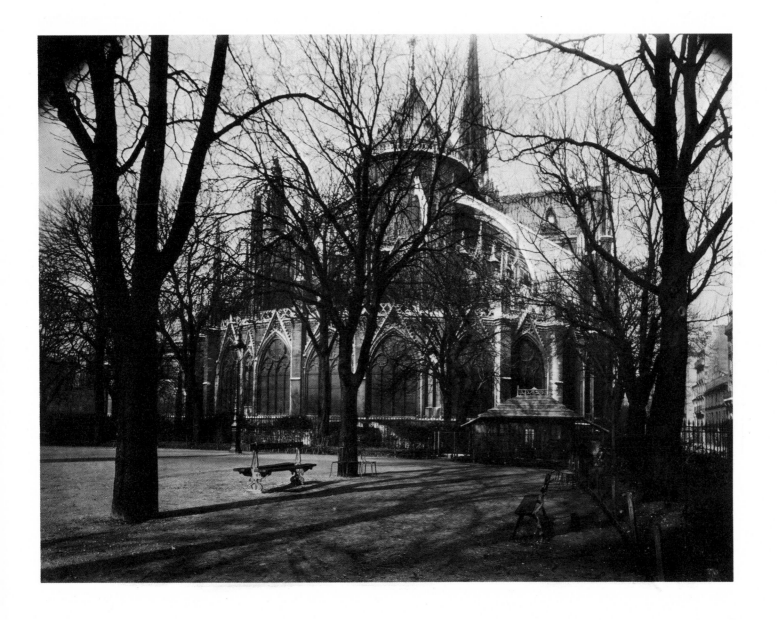

And certainly every part one saw of the church served to distinguish the whole from any other building by a kind of general feeling which pervaded it, but it was in the steeple that the church seemed to display a consciousness of itself, to affirm its individual and responsible existence. It was the steeple which spoke for the church.

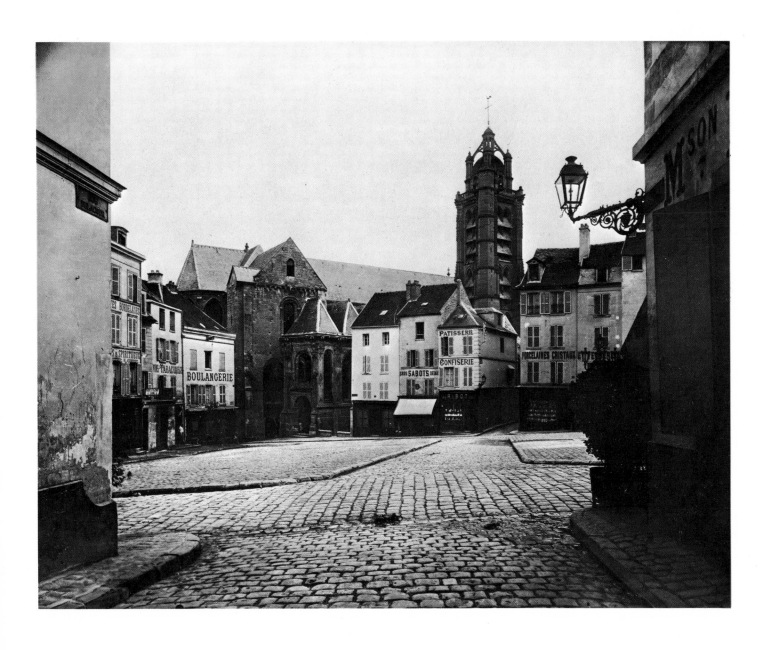

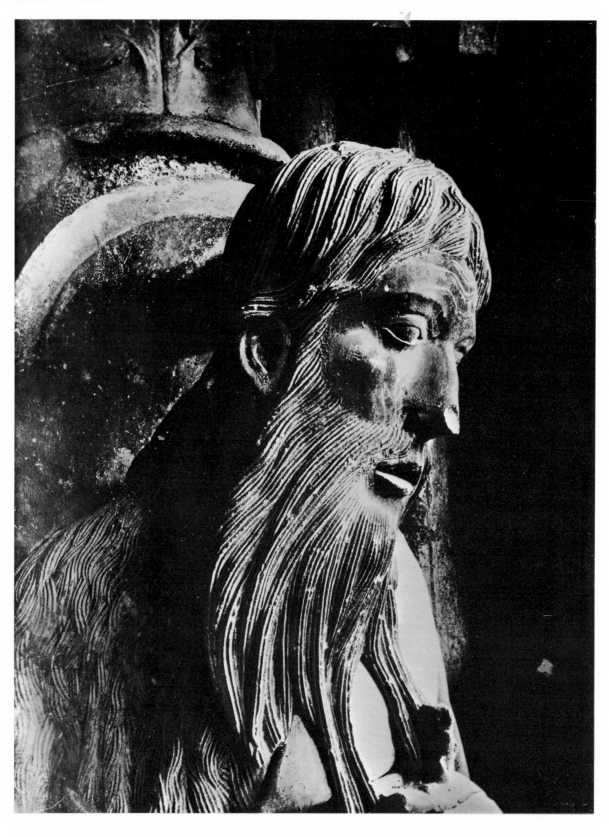

This work of the artist, to seek to discern something different underneath material, experience, words, is exactly the reverse of the process which, during every minute that we live with our attention diverted from ourselves, is being carried on within us by pride, passion, intelligence and also by our habits, when they hide our true impressions from us by burying them under the mass of nomenclatures and practical aims which we erroneously call life. After all, that art, although so complicated, is actually the only living art. It alone expresses to others and discloses to us our own life, that life which cannot be 'observed' and the visible manifestations of which need to be translated and often read backwards and deciphered with much effort.

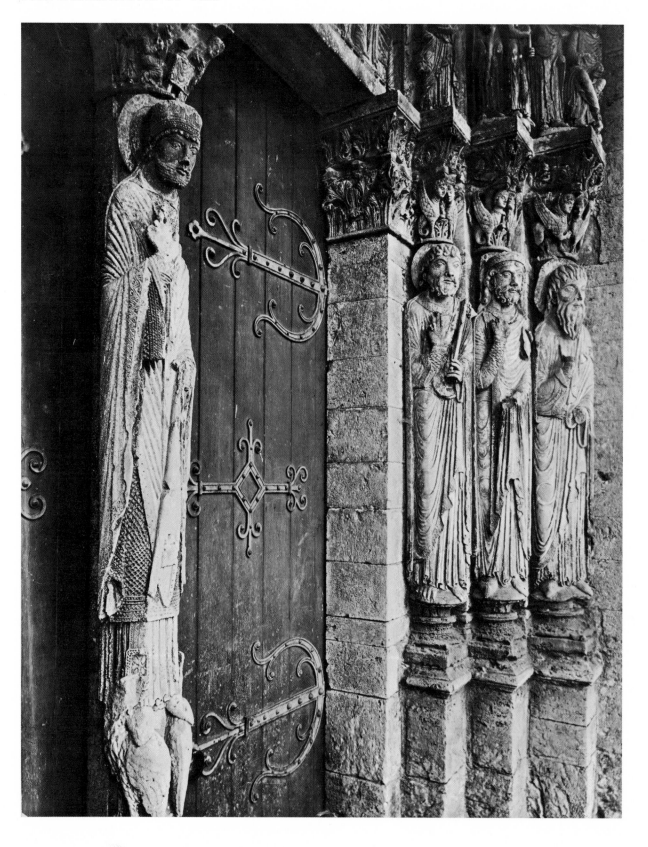

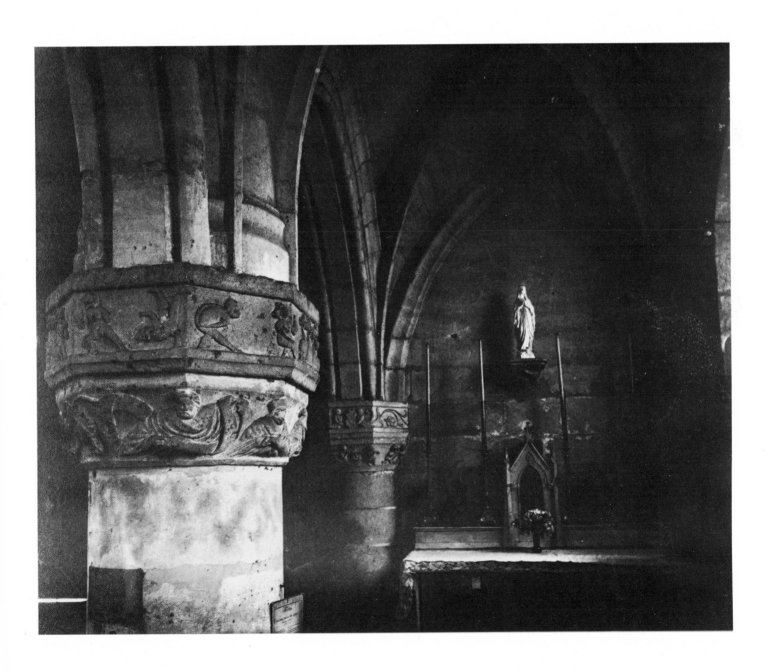

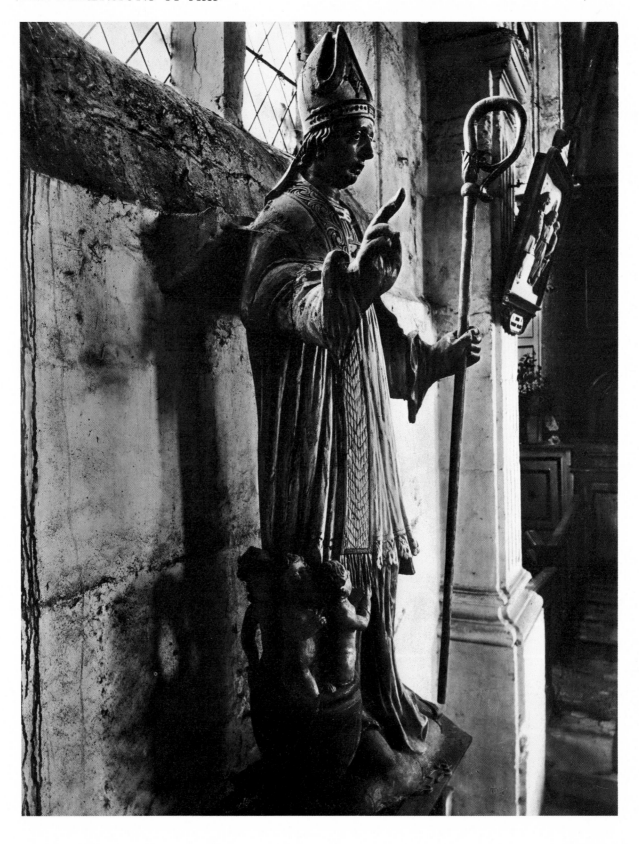

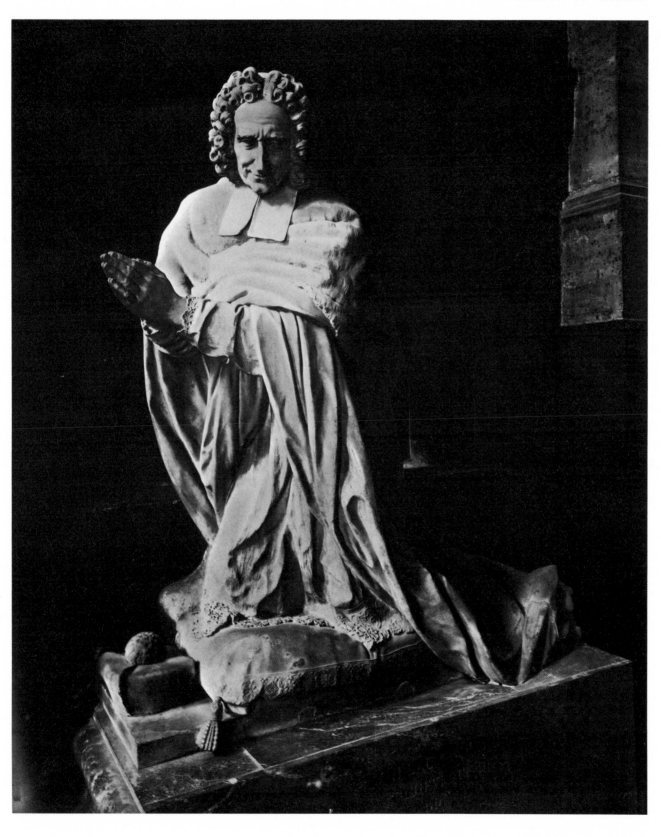

. . . how was one to choose, any more than between individual people, who are not inter-changeable, between Bayeux, so lofty in its noble coronet of rusty lace, whose highest point caught the light of the old gold of its second syllable; Vitré, whose acute accent barred its ancient glass with wooden lozenges; gentle Lamballe, whose whiteness ranged from egg-shell yellow to a pearly grey; Coutances, a Norman Cathedral, which its final consonants, rich and yellowing, crowned with a tower of butter; Lannion with the rumble and buzz, in the silence of its village street, of the fly on the wheel of the coach; Questambert, Pontorson, ridiculously silly and simple, white feathers and yellow beaks strewn along the road to those well-watered and poetic spots; Benodet, a name scarcely moored that seemed to be striving to draw the river down into the tangle of its seaweeds; Pont-Aven, the snowy, rosy flight of the wing of a lightly poised coif, tremulously reflected in the greenish waters of a canal; Quimperlé, more firmly attached, this, and since the Middle Ages, among the rivulets with which it babbled, threading their pearls upon a grey back-ground, like the pattern made, through the cobwebs upon a window, by rays of sunlight changed into blunt points of tarnished silver?

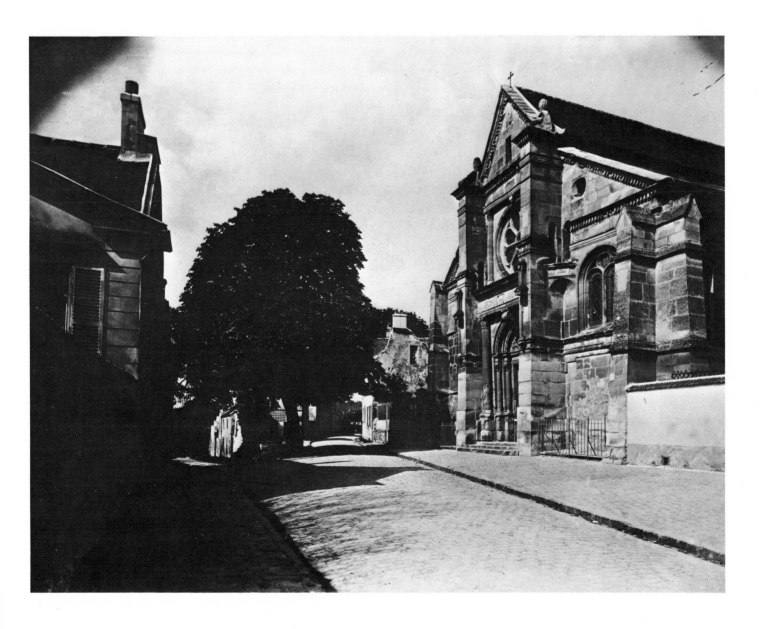

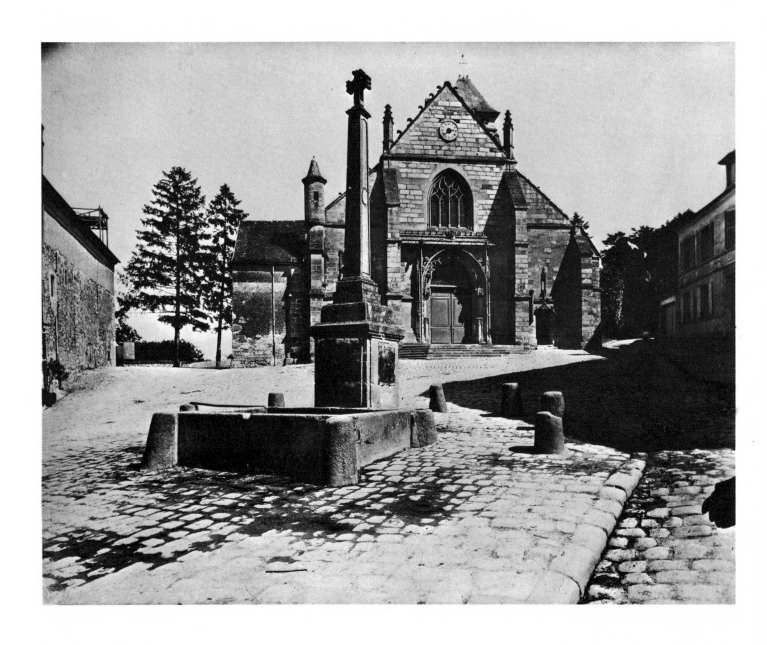

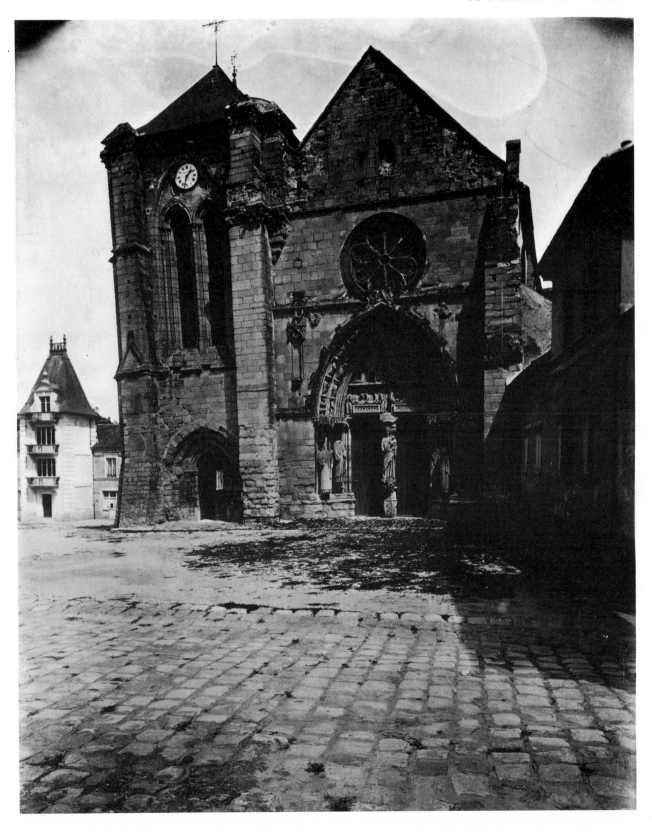

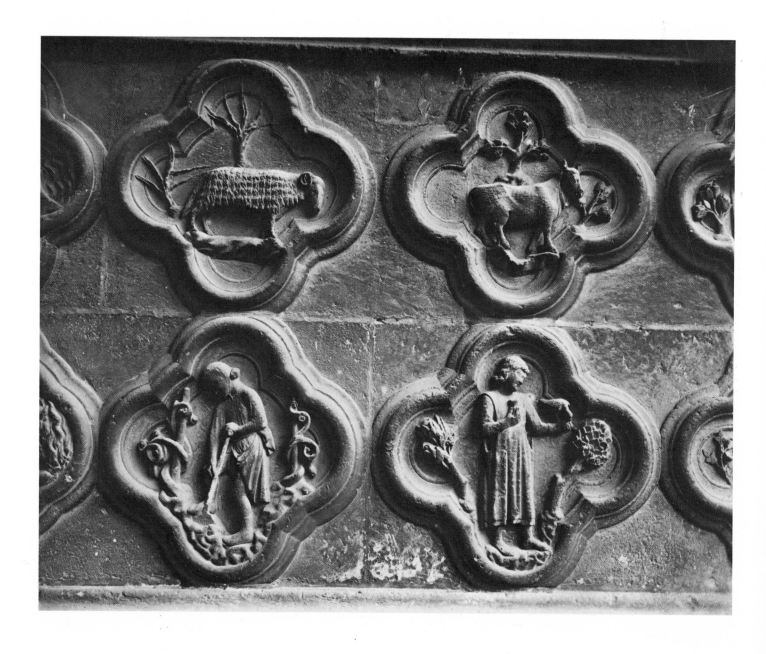

One could see that the ideas which the mediaeval artist and the mediaeval peasant . . . had of classical and of early Christian history, ideas whose inaccuracy was atoned for by their honest simplicity, were derived not from books, but from a tradition at once ancient and direct, unbroken, oral, degraded, unrecognisable, and alive.

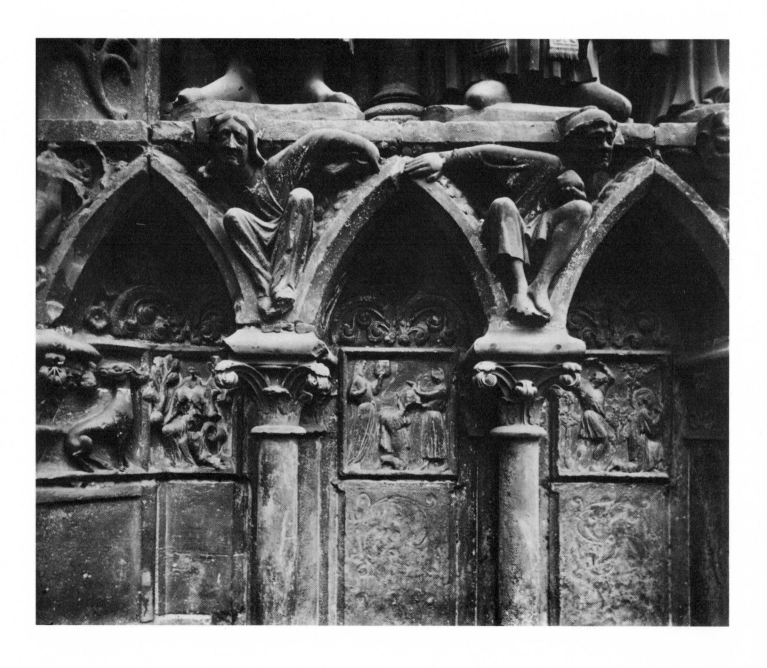

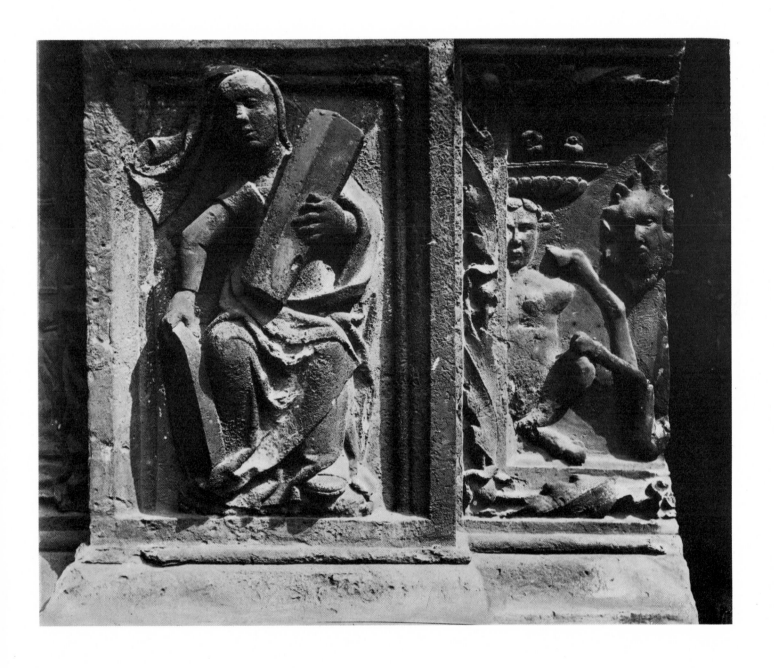

To obtain a closer view of a marble goddess who had been carved in the act of leaping from her pedestal and, alone in a great wood which seemed to be consecrated to her, filled it with the mythological terror, half animal, half divine, of her frenzied bounding, Albertine climbed a grassy slope while I waited for her in the road.

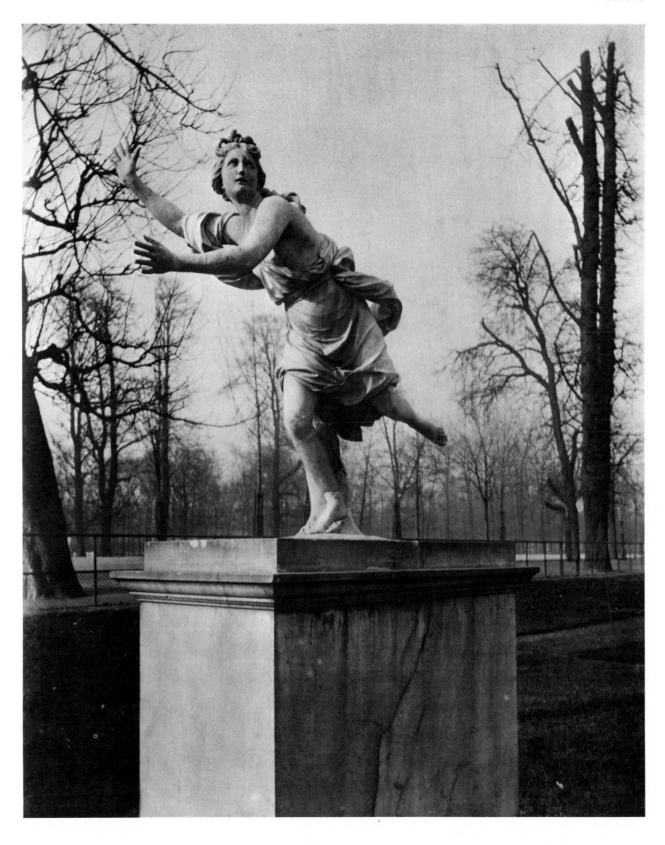

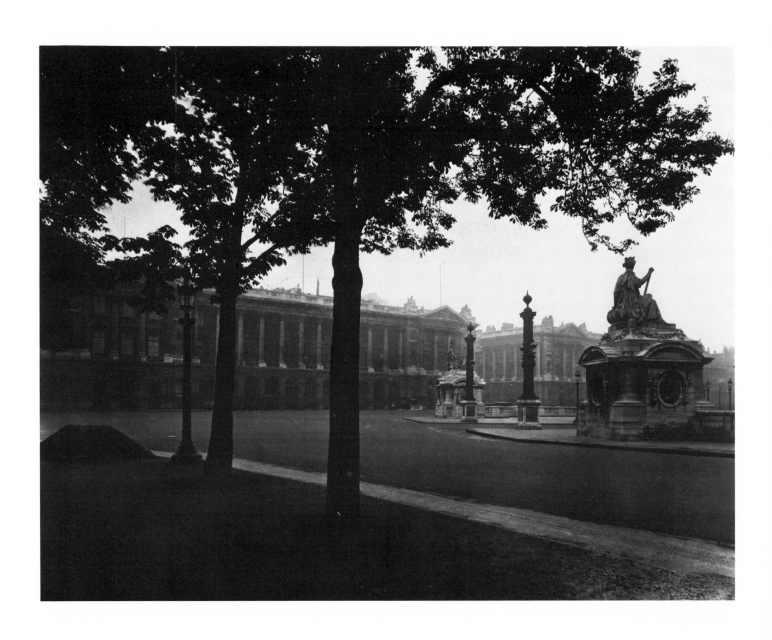

For the monuments of Paris had been substituted, pure, linear, without depth, a drawing of the monuments of Paris, as though in an attempt to recall the appearance of a city that had been destroyed.

"Have you been to look at the fountain?" he asked me in a tone that was affirmative rather than questioning. "It is quite pretty, ain't it? It is marvellous. It might be made better still, naturally, if certain things were removed, and then there would be nothing like it in France. But even as it stands, it is quite one of the best things."

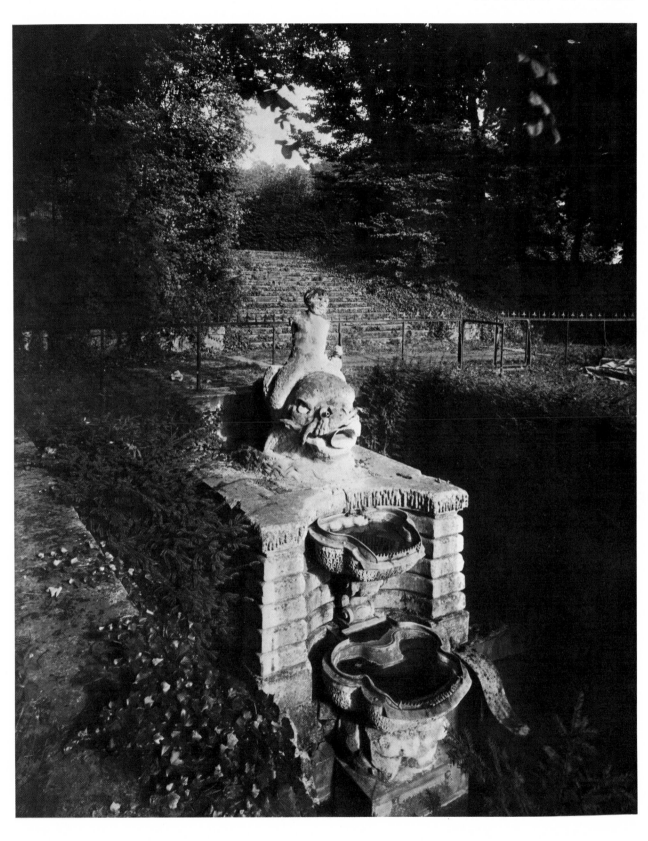

... even though our life be a roving one, our memory is sedentary and, no matter how ceaselessly we may rush about, our recollections, riveted to the places from which we tear ourselves away, continued to lead their stay-at-home existence there, like the temporary friends a traveller makes in a town and has to abandon when he leaves because it is there that they, who do not go away, will end their journey and their lives, as if he were still there, by the church, before the door, under the trees of the promenade.

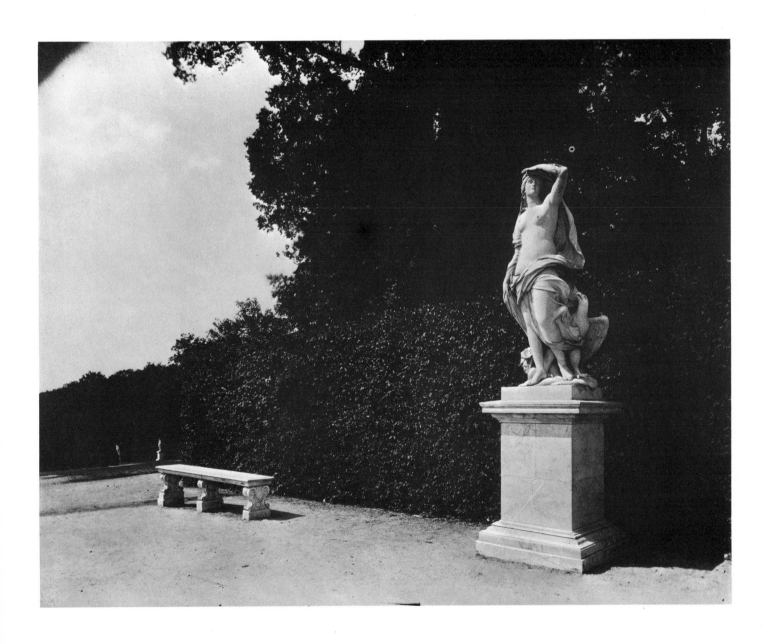

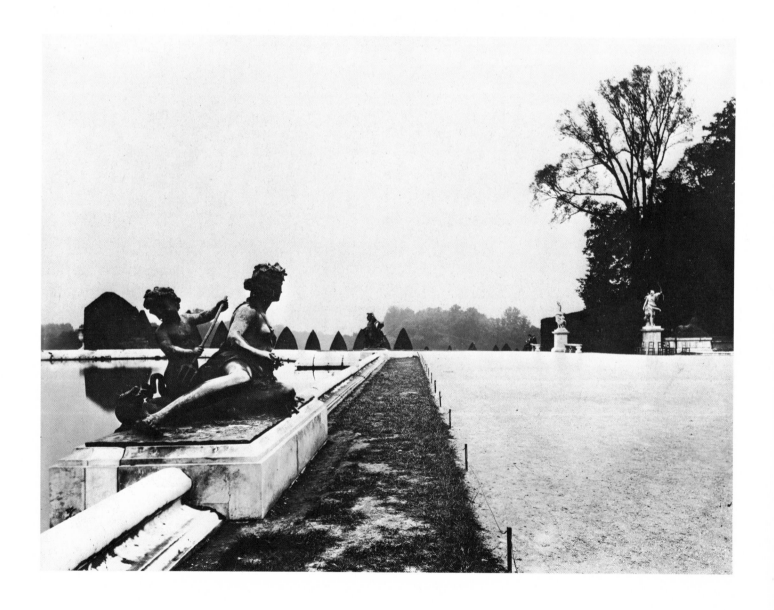

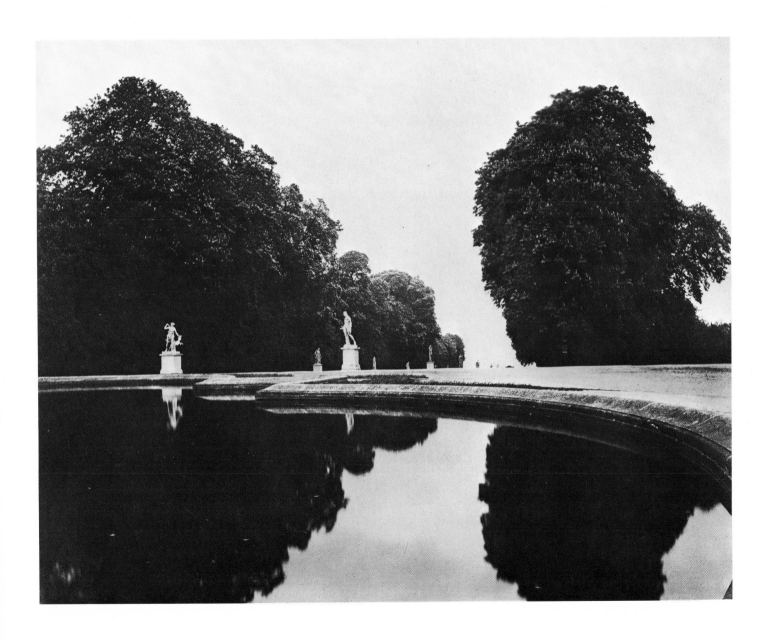

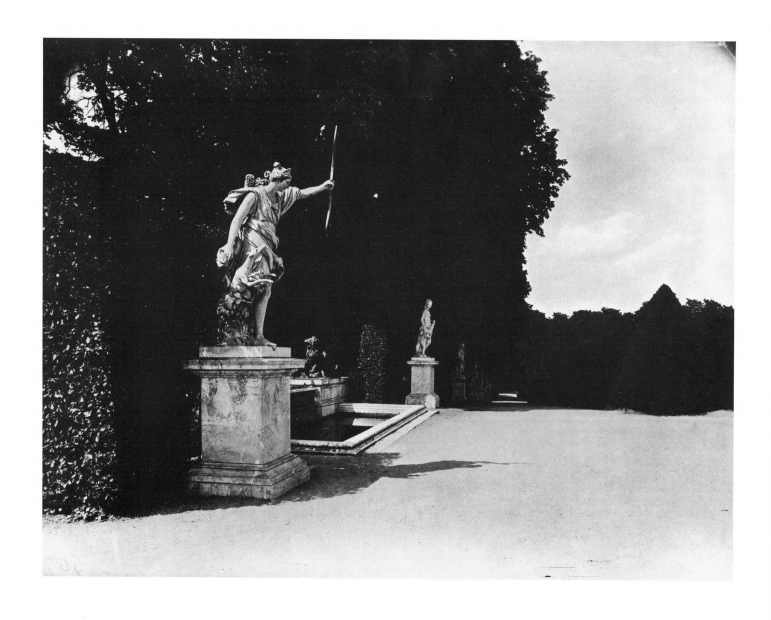

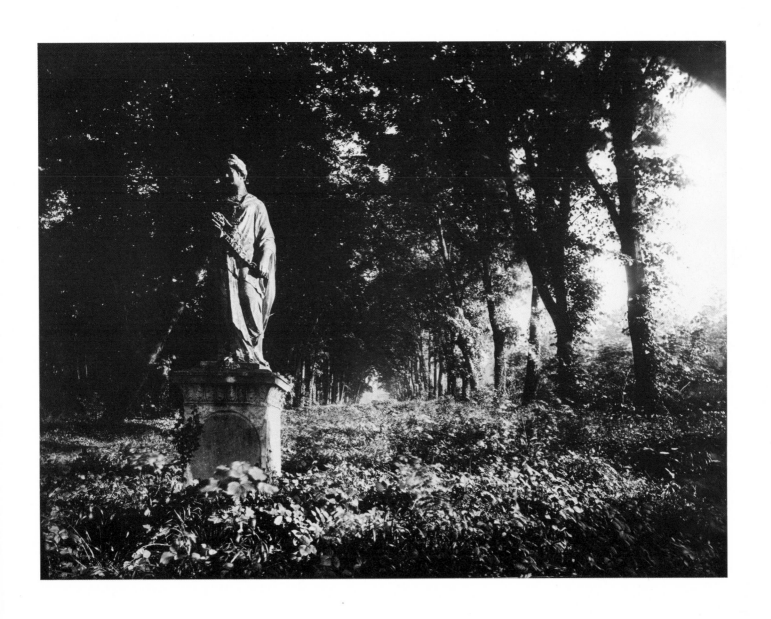

. . . the sharply cut shadows of the wrought iron of the balustrade were outlined in black like a capricious vegetation, with a fineness in the delineation of their smallest details which seemed to indicate a deliberate application, an artist's satisfaction, and with so much relief, so velvety a bloom in the restfulness of their sombre and happy mass that in truth those large and leafy shadows which lay reflected on that lake of sunshine seemed aware that they were pledges of happiness and peace of mind.

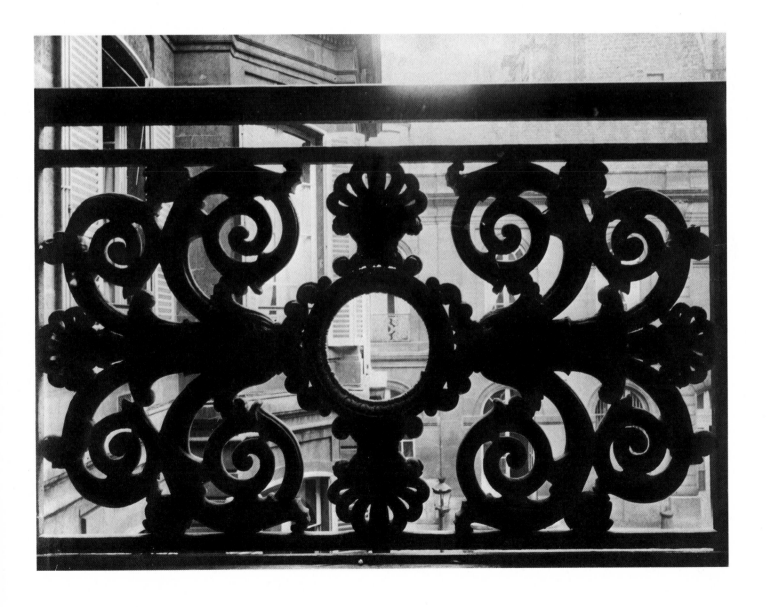

Nothing was left now but a few stumps of towers, hummocks upon the broad surface of the fields, hardly visible, broken battlements over which, in their day, the bowmen had hurled down stones, the watchmen had gazed out over Novepont, Clairefontaine, Martinville-le-Sec, Bailleau-l'Exempt, fiefs all of them of Guermantes, a ring in which Combray was locked; but fallen among the grass now, levelled with the ground, climbed and commanded by boys from the Christian

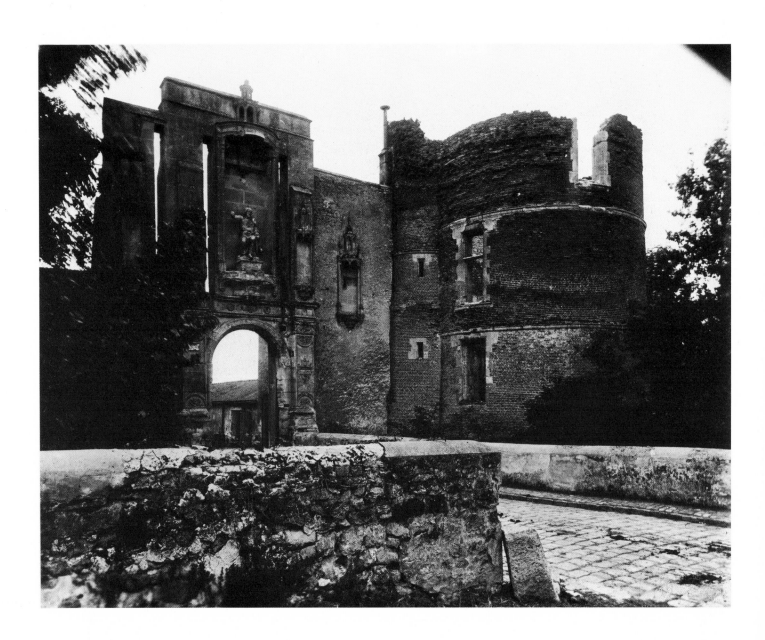

Brother's school, who came there in their playtime, or with lesson-books to be conned; emblems of a past that had sunk down and well-nigh vanished under the earth, that lay by the water's edge now, like an idler taking the air, yet giving me strong food for thought, making the name of Combray connote to me not the little town of to-day only, but an historic city vastly different, seizing and holding my imagination by the remote, incomprehensible features which it half-concealed beneath a spangled veil of buttercups.

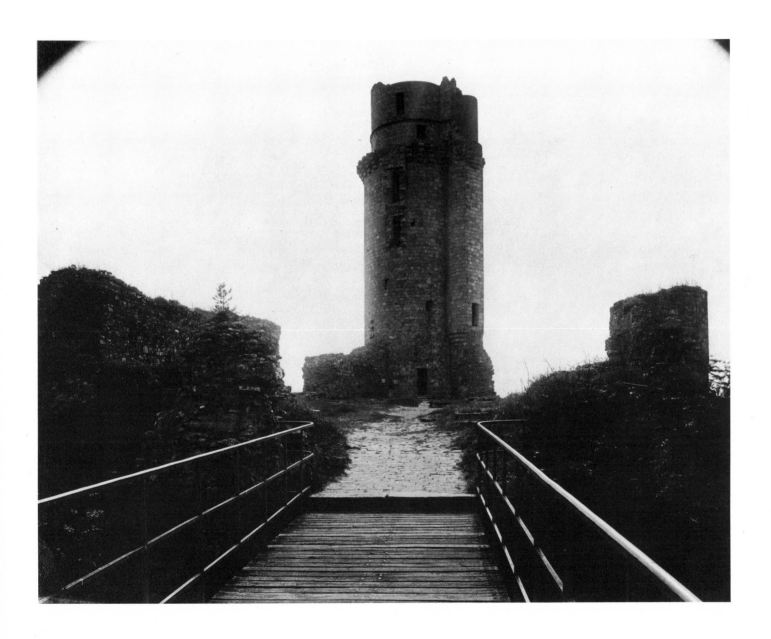

The Fabric of Nature

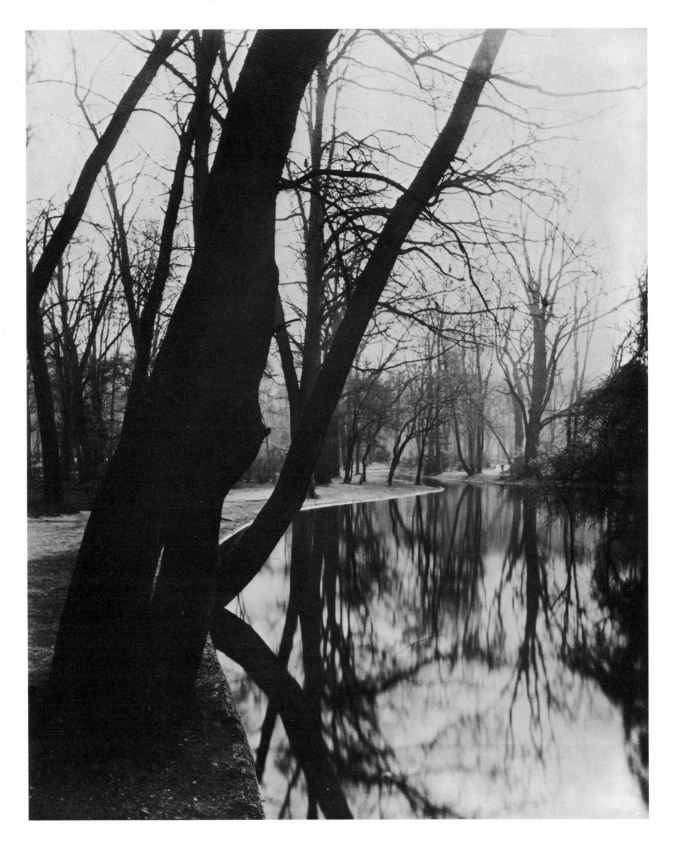

Nature began again to reign over the Bois, from which had vanished all trace of the idea that it was the Elysian Garden of Woman; above the gimcrack windmill the real sky was grey; the wind wrinkled the surface of the Grand Lac in little wavelets, like a real lake; large birds passed swiftly over the Bois, as over a real wood, and with shrill cries perched, one after another, on the great oaks which, beneath their Druidical crown, and with Dodonaic majesty, seemed to proclaim the unpeopled vacancy of this estranged forest, and helped me to understand how paradoxical it is to seek in reality for the pictures that are stored in one's memory, which must inevitably lose the charm that comes to them from memory itself and from their not being apprehended by the senses.

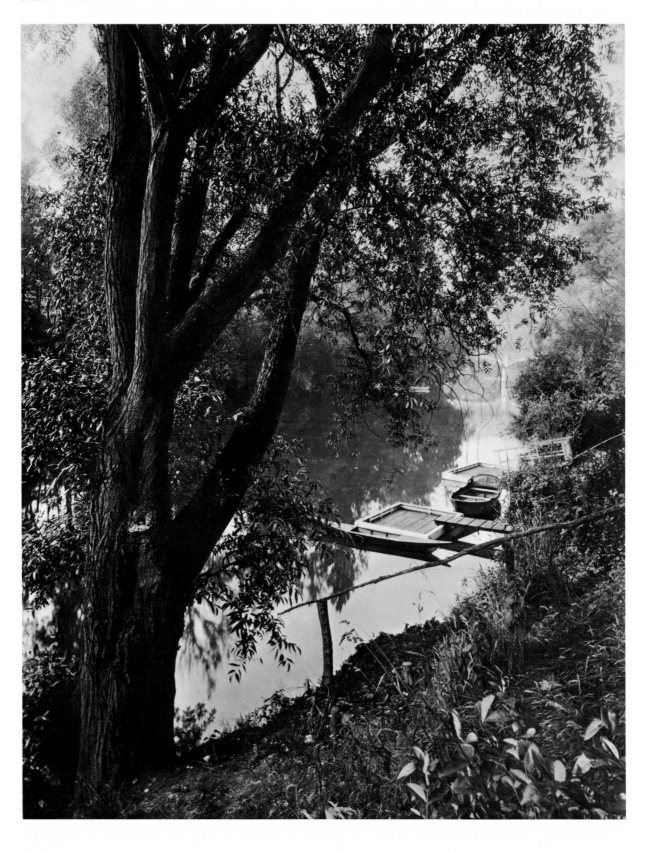

Parisian, get up, get up, come out and picnic in the country, and take a boat on the river, under the trees, with a pretty girl; get up, get up!

The great charm of the "Guermantes Way" was that we had beside us, almost all the time, the course of the Vivonne. We crossed it first, ten minutes after leaving the house by a foot bridge called the Pont-Vieux. And every year, when we arrived at Combray, on Easter morning, . . . if the weather was fine, I would run there to see . . . the river flowing past, sky-blue already between banks still black and bare.

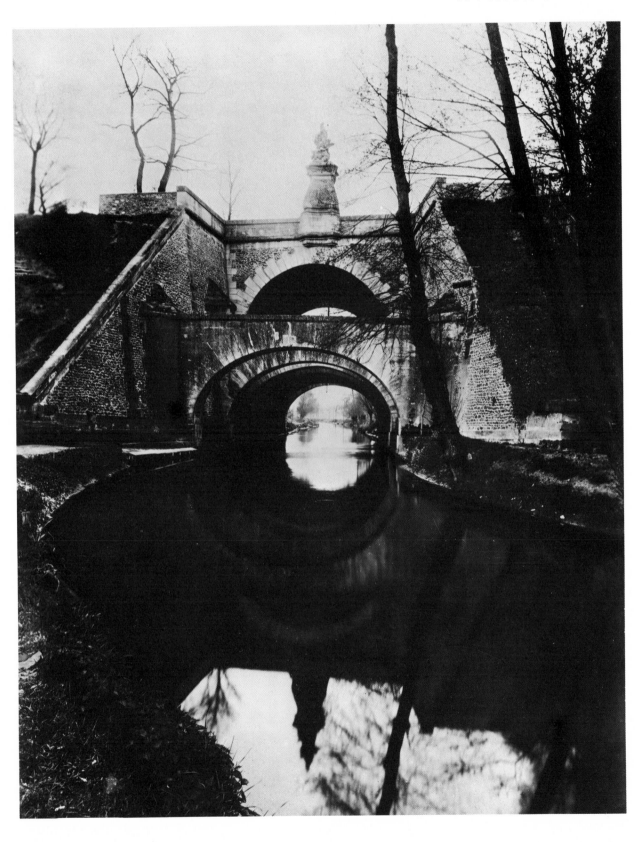

Presently the course of the Vivonne became choked with water-plants. At first they appeared singly, a lily, for instance, which the current, across whose path it had unfortunately grown, would never leave at rest for a moment, so that, like a ferry-boat mechanically propelled, it would drift over to one bank only to return to the other, eternally repeating its double journey. Thrust towards the bank, its stalk would be straightened out, lengthened, strained almost to breaking-point until the current again caught it, its green moorings swung back over their anchorage and brought the unhappy plant to what might fitly be called its starting-point, since it was fated not to rest there a moment before moving off once again.

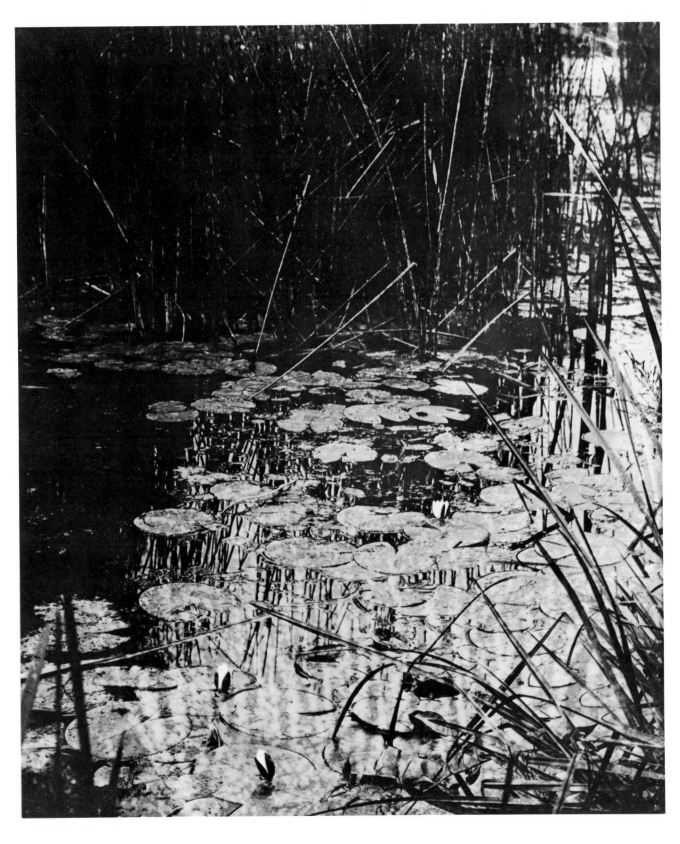

Here and there, on the surface, floated, blushing like a strawberry, the scarlet heart of a lily set in a ring of white petals.

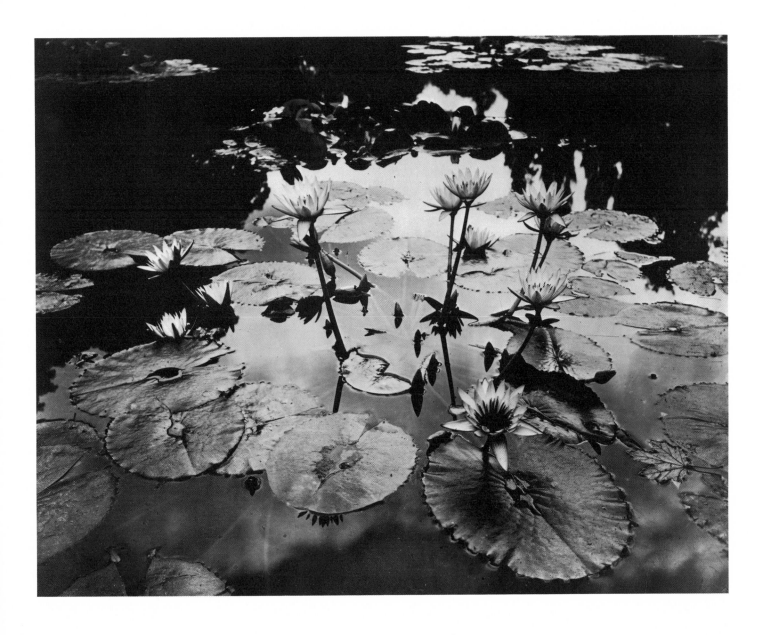

In front of us a path bordered with nasturtiums rose in the full glare of the sun towards the house.

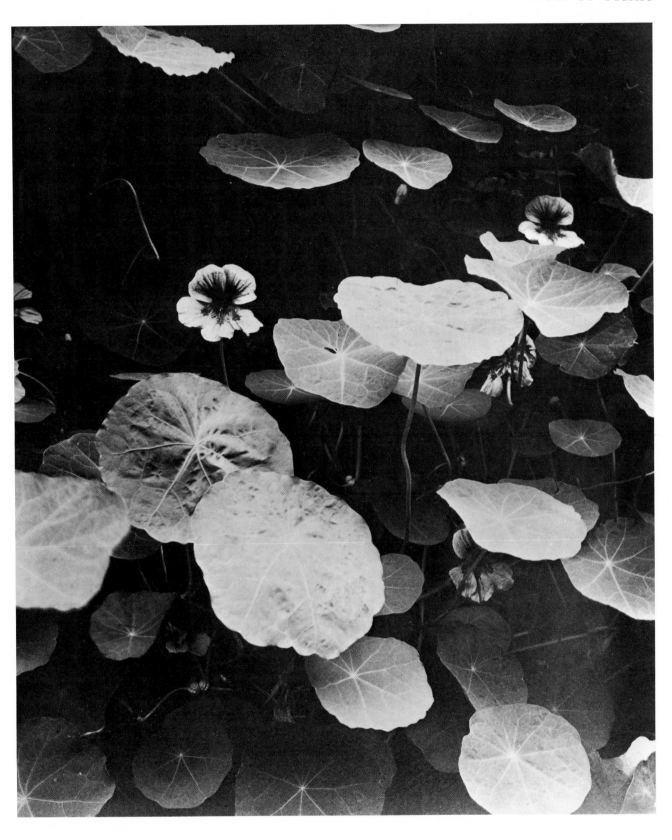

... at the foot of the path which led down to this artificial lake, there might be seen, in its two tiers woven of trailing forget-me-nots below and of periwinkle flowers above, the natural, delicate, blue garland which binds the luminous, shadowed brows of water-nymphs; while the iris, its swords sweeping every way in regal profusion, stretched out over agrimony and water-growing king-cups the lilied sceptres, tattered glories of yellow and purple, of the kingdom of the lake.

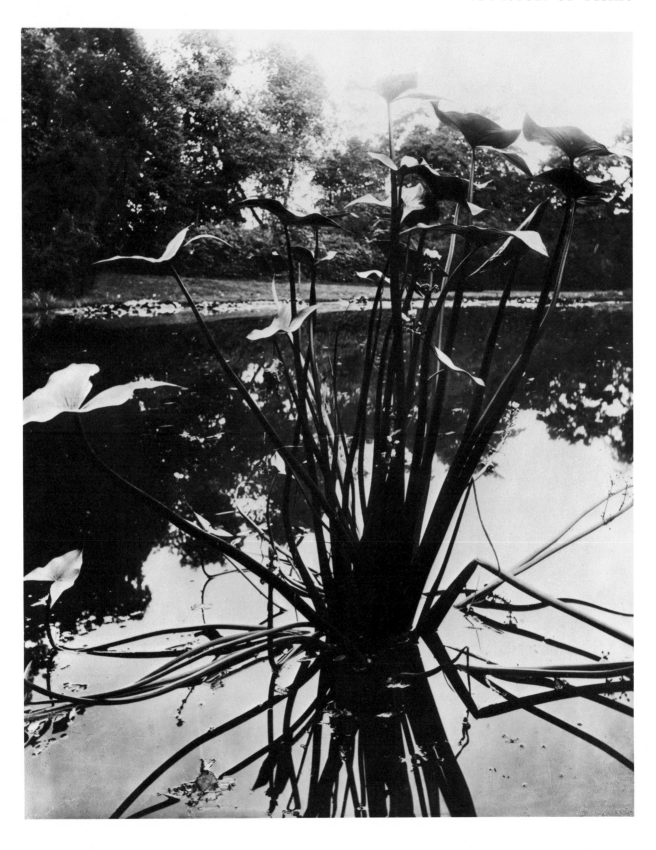

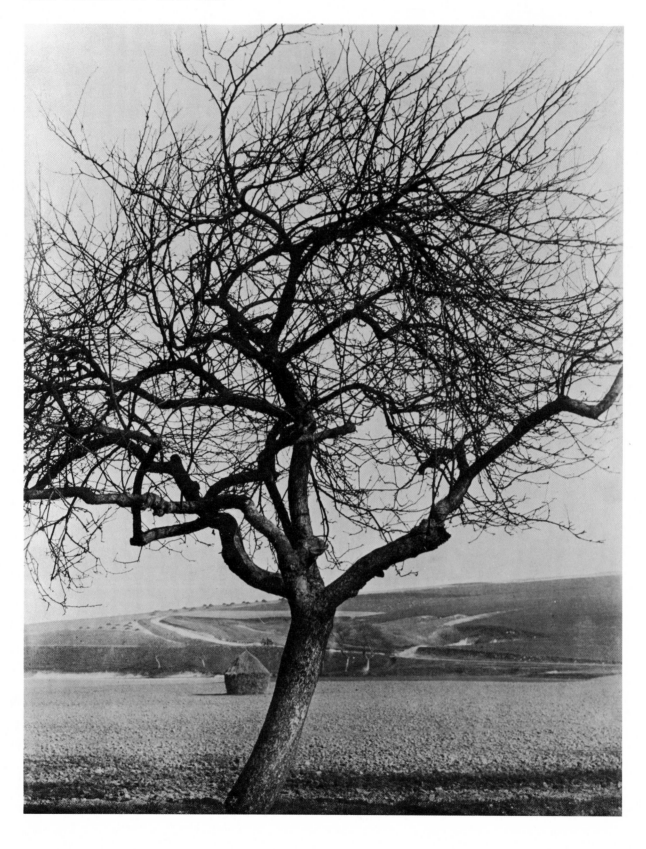

. . . we could see here and there an apple-tree, stripped it was true of its blossom, and bearing no more now than a fringe of pistils, but sufficient even so to enchant me since I could imagine, seeing those inimitable leaves, how their broad expanse, like the ceremonial carpet spread for a wedding that was now over, had been but the other day swept by the white satin train of their blushing flowers.

. . . they were in full bloom, marvellous in their splendour, their feet in the mire beneath their ball-dresses, taking no precaution not to spoil the most marvellous pink satin that was ever seen, which glittered in the sunlight . . .

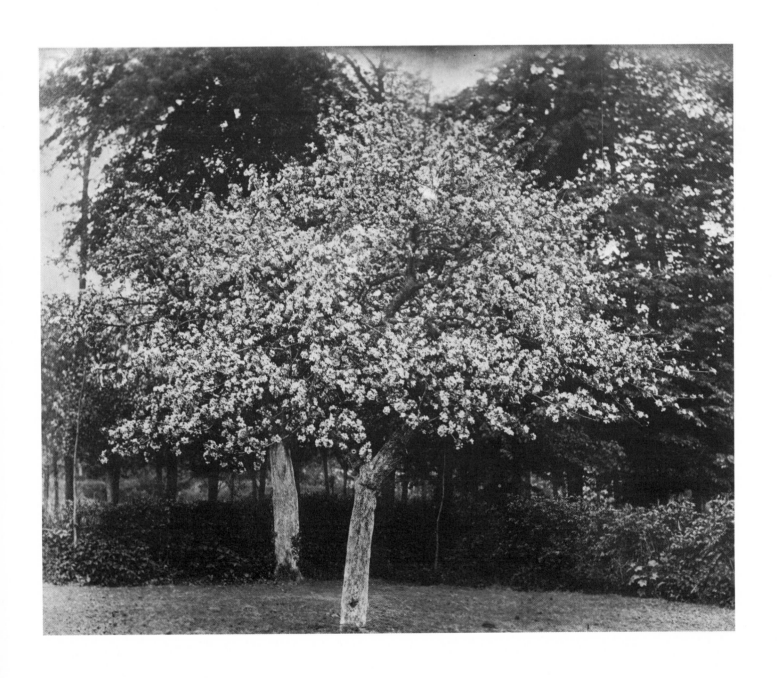

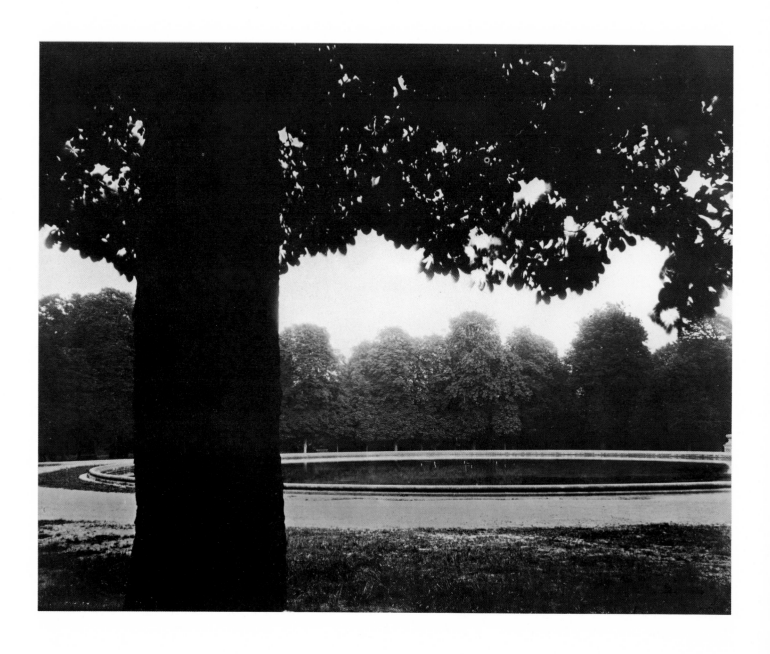

I passed through forest groves in which the morning light, breaking them into new sections, lopped and trimmed the trees, united different trunks in marriage, made nosegays of their branches. It would skilfully draw towards it a pair of trees; making deft use of the sharp chisel of light and shade, it would cut away from each of them half of its trunk and branches, and, weaving together the two halves that remained, would make of them either a single pillar of shade, defined by the surrounding light, or a single luminous phantom whose artificial, quivering contour was encompassed in a network of inky shadows. When a ray of sunshine gilded the highest branches, they seemed, soaked and still dripping with a sparkling moisture, to have emerged alone from the liquid, emerald-green atmosphere in which the whole grove was plunged as though beneath the sea.

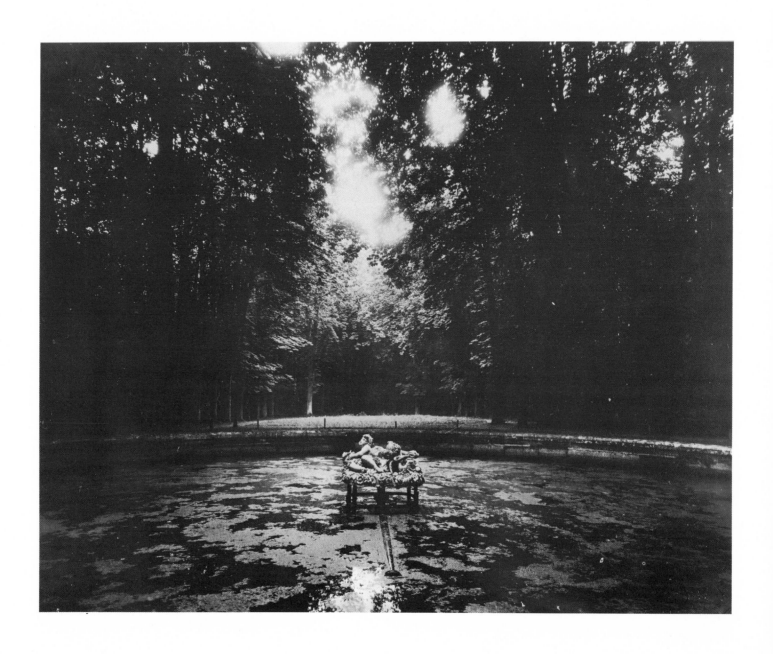

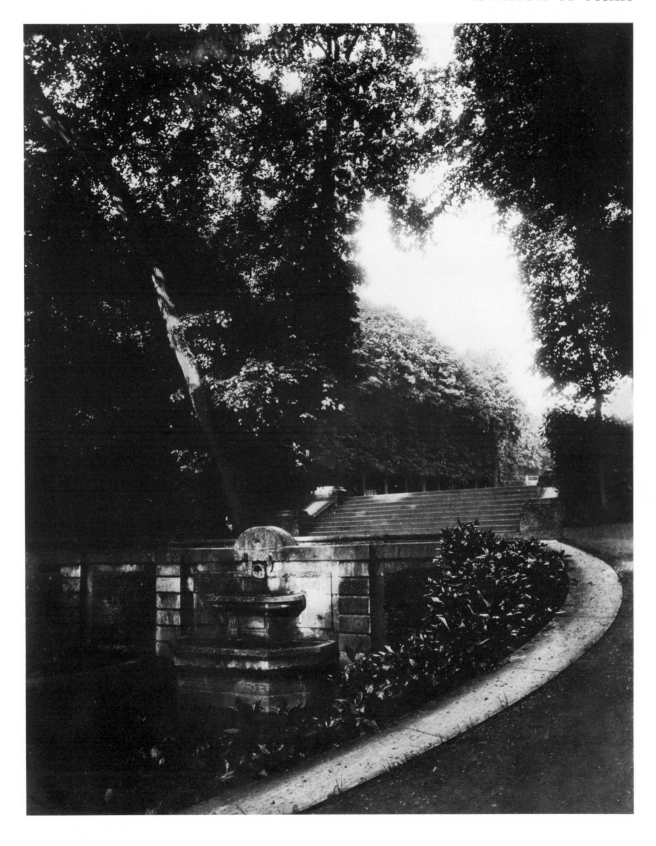

Once more I left my carriage shortly before reaching the house of the Princesse de Guermantes and fell to thinking again of the lassitude and ennui with which I had endeavoured the day before, in what is considered one of the most beautiful parts of France, to describe the line that separated sunlight from shadow on the tree trunks.

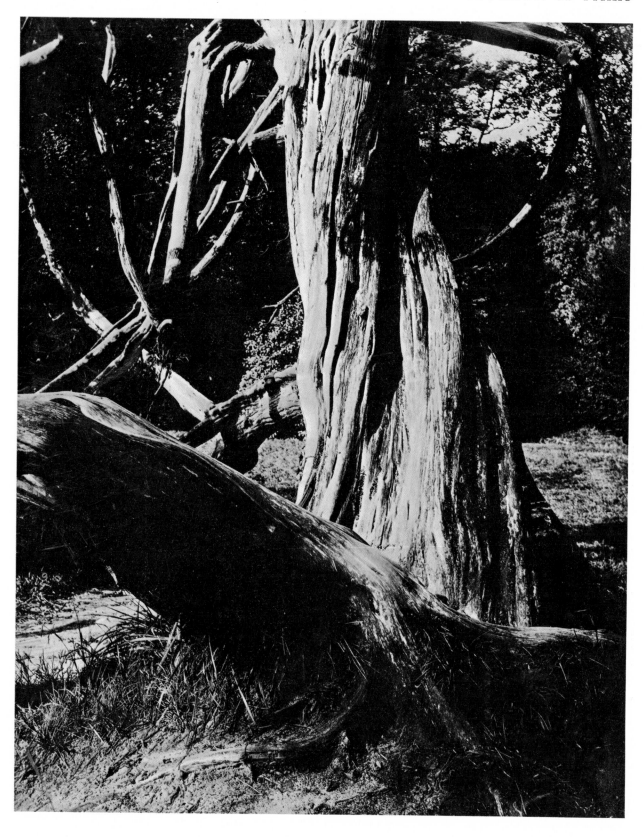

A river running beneath the bridges of a town was caught from a certain point of view so that it appeared entirely dislocated, now broadened into a lake, now narrowed into a rivulet, broken elsewhere by the interruption of a hill crowned with trees among which the burgher would repair at evening to taste the refreshing breeze . . .

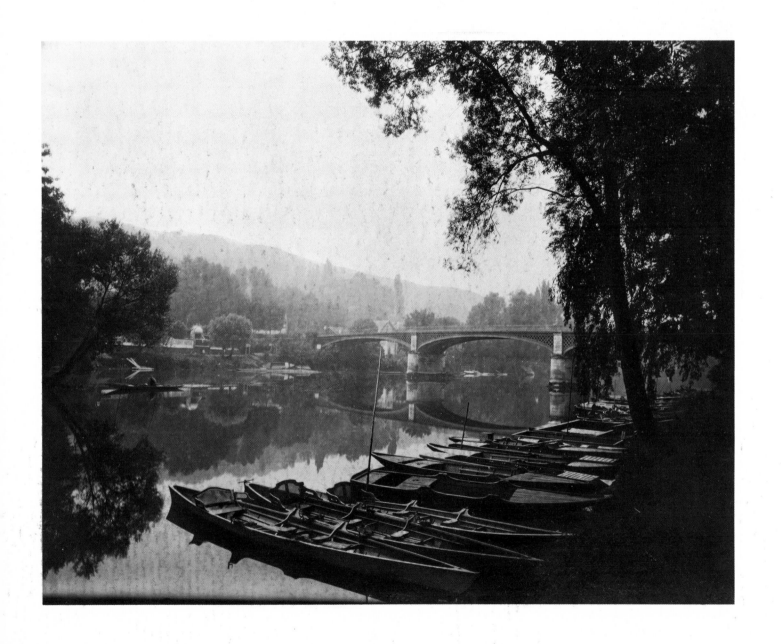

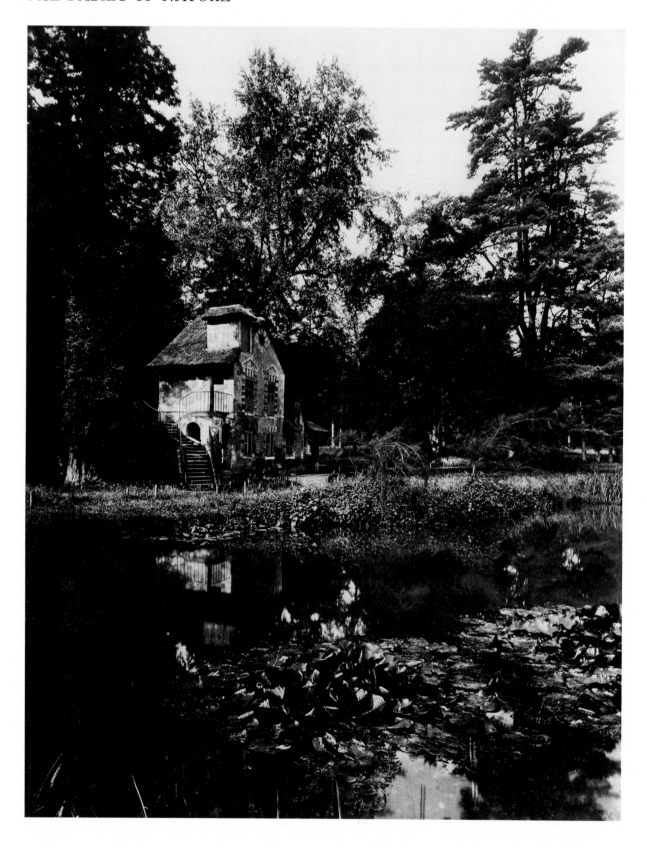

But to our right the park stretched away into the distance, on level ground. Overshadowed by the tall trees which stood close around it . . . an "ornamental water" had been constructed . . . but, even in his most artificial creations, nature is the material upon which man has to work; certain spots will persist in remaining surrounded by the vassals of their own special sovereignty, and will raise their immemorial standards among all the "laid-out" scenery of a park, just as they would have done far from any human interference, in a solitude which must everywhere return to engulf them, springing up out of the necessities of their exposed position, and superimposing itself upon the work of man's hands.

But the beauty for which the firs and acacias of the Bois de Boulogne made me long, more disquieting in that respect than the chestnuts and lilacs of Trianon which I was going to see, was not fixed somewhere outside myself in the relics of an historical period, in works of art, in a little temple of love at whose door was piled an oblation of autumn leaves ribbed with gold.

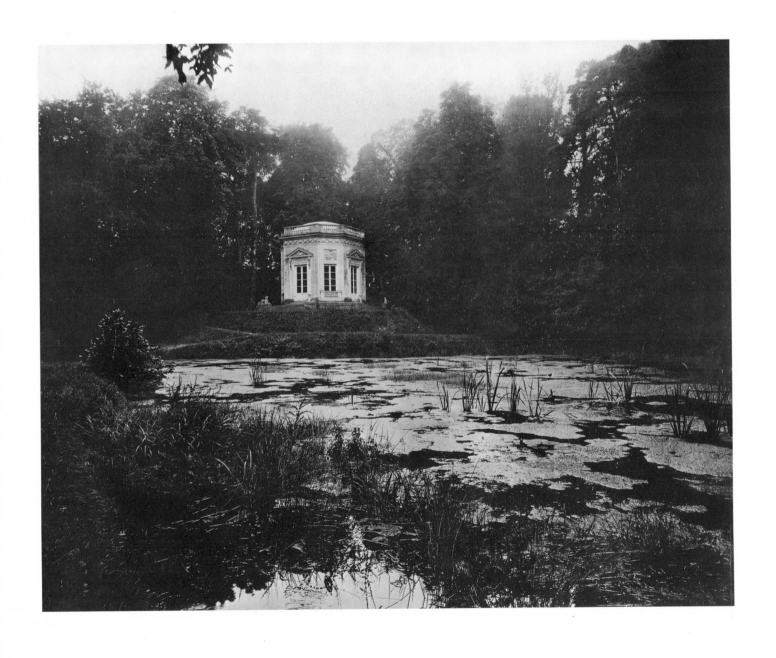

. . . this fishing fleet seemed less to belong to the water than, for instance, the churches of Criquebec which, in the far distance, surrounded by water on every side because you saw them without seeing the town, in a powdery haze of sunlight and crumbling waves, seemed to be emerging from the waters, blown in alabaster or in sea-foam, and, enclosed in the band of a particoloured rainbow, to form an unreal, a mystical picture.

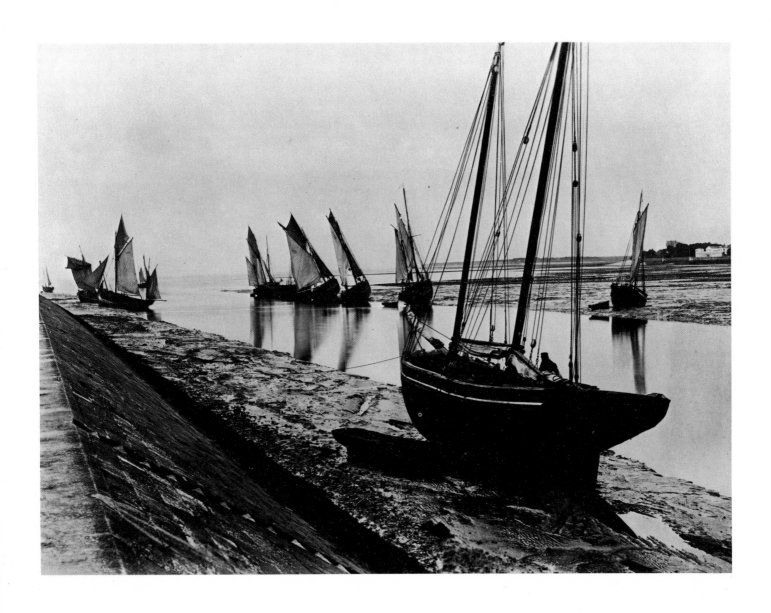

. . . one could see through the trees the sun setting as though it had been merely some place farther along the road, a forest place and distant, which we should not have time to reach that evening.

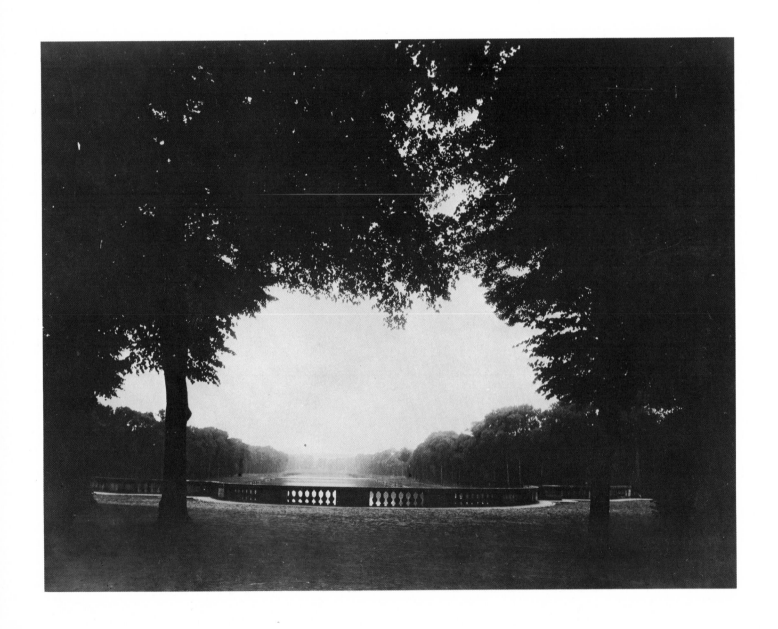

Contents

PRODUCTION
EDITA
LAUSANNE

Printed in Italy and bound in Switzerland